IMAGES
of America

CONCORD

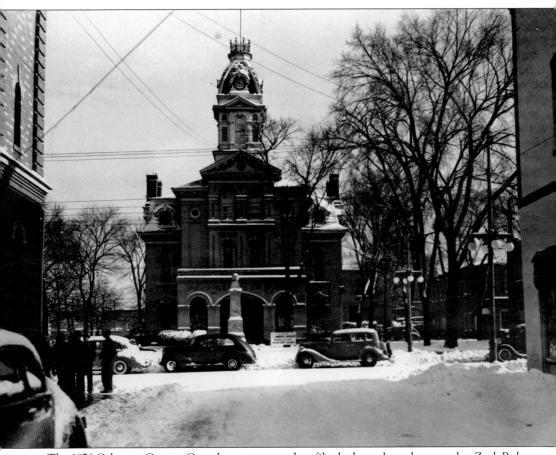

The 1876 Cabarrus County Courthouse, captured on film by legendary photographer Zack Roberts on January 24, 1940, has remained Concord's most recognizable landmark since its construction. The building was scheduled for demolition in the 1970s but was restored after a preservation effort that formed the nonprofit organization Historic Cabarrus. The marble monument in front of the building commemorates the community's Confederate dead. (Courtesy of Historic Cabarrus Association, Inc.)

ON THE COVER: Concord's emerging textile empire relied not only on the ingenuity of its financiers but also on the backbreaking labor provided by its workforce. This 1900 photograph depicts the Cabarrus Mill on Corban (also Corbin) Street (now Corban Avenue), which was later expanded and became known as Plant 5 of Cannon Mills. (Courtesy of the Kannapolis Public Library.)

IMAGES
of America

CONCORD

Michael Eury
Foreword by Helen Arthur-Cornett

ARCADIA
PUBLISHING

Published by Arcadia Publishing
Charleston, South Carolina

Printed in the United States of America

Library of Congress Control Number: 2010938687

For all general information, please contact Arcadia Publishing:
Telephone 843-853-2070
Fax 843-853-0044
E-mail sales@arcadiapublishing.com
For customer service and orders:
Toll-Free 1-888-313-2665

Visit us on the Internet at www.arcadiapublishing.com

To the board of directors of Historic Cabarrus Association, Inc., for their passion for our city's rich heritage and their determination to keep it alive.

CONTENTS

FOREWORD

With the publication of this lively compilation of photographs from the past of Concord, North Carolina, the historical worth of author Michael Eury—the compelling executive director of Historic Cabarrus Association, Inc.—can well be measured.

In the few years he has headed the association, he has wrought near-miracles, infusing this local history-preserving group with enthusiasm and stirring up a strong desire for us—and others—to do even more to collect and compile and save everything possible of Concord's 200-plus years of history.

Of course, Eury, a native of Concord, came to the organization with a career background rich in many successes and endeavors—and literally full of excitement for anything historic hereabouts.

So the Historic Cabarrus Association, Inc., board of directors did not find it surprising that he would tackle a major publication. They threw him their wholehearted support.

Arcadia Publishing's Images of America imprint offers Michael the perfect vehicle for exploring our city's past: a pictorial glance back at Concord, her people, her leaders, significant events, and lots of everyday trivia—those fascinating bits and pieces of local life that never fail to fascinate history lovers.

Michael's was not an easy task, rounding up hundreds of old photograph from way back. He scouted every location he could find—the Concord Museum archives, retired news photographers, local photograph enthusiasts, various clubs, local organizations, sports lovers, and, well, you name it. Eury was there, requesting, discovering, and getting permission to use these wonderful, if aging, pictures from our past.

With boundless energy and drive, he sorted, arranged, and placed each photograph, then wrote the information so vital to accompany each image.

For any community, a book such as this one is bound to be an asset, and not just for our locals.

Newcomers have poured into this area, pushing us from a quiet town of about 25,000 a decade or so ago to a thriving municipality—today reaching toward a population of 80,000 people. They well might find these photographs of our past illustrate our own special history, and find Concord as compelling as any of the small towns over the United States.

Old-timers living in Concord—many of whose ancestors helped pioneer this area in the mid-1700s—will wax nostalgic over the old photographs. They will laugh at some of our foibles from those early times, shake their heads over the major fires and tornadoes, try to find old chums in the pictures, and try themselves to recall these old history-making events.

And they will be reminded of other things that happened in those bygone years, things that they would like to see remembered in old photographs.

That is one of the major benefits of this book—its ability to spur more interest here, more participation from our people, all over the city.

This, in turn, will give more impetus to the board of directors and many members of Historic Cabarrus Association, Inc., workers and volunteers who for many years have struggled, literally,

first to preserve the Historic Cabarrus County Courthouse and presently to take on other historic preservation projects. The original board's prime job was raising funds, year in and year out, to meet the costs of keeping the Historic Cabarrus County Courthouse sound. Those early years were not easy ones for the board, and there was an element of burnout among members.

However, these days, at the top of the list of Historic Cabarrus Association, Inc.'s efforts is to find housing for the Concord Museum (formerly Confederate Memorial Hall), which as of now is crowded into a small room in the old Belk building in downtown Concord, at 11 Union Street South, Suite 104. There is only space for about a 10th of the thousands of items that the museum has collected since its organization in the late 1930s by the local United Daughters of the Confederacy.

Now, finding a satisfactory building is a difficult task, as treasured old items—especially the aging battle flags from the 1860s and other fragile historical materials—must have proper surroundings: dust free, cool temperatures, proper cabinets, and glass cases.

But there is hope: Michael Eury is heading this project. He explores every vacant building in downtown Concord and other close-in regions of the city. And as I write this, there *are* a couple of interesting prospects…

The publication of this book, it is hoped, will enhance our chances and entice readers everywhere to pitch in to help Historic Cabarrus Association, Inc., record our history to the hilt.

And that, of course, will ultimately lead the organization to take on even more projects aimed at saving other of our often-endangered historic sites. You can find our more information about Historic Cabarrus Association, Inc., by visiting our Web site, www.historiccabarrus.org, or by stopping in at the Concord Museum, open Tuesdays through Saturdays from 11:00 a.m. until 3:00 p.m.

Michael Eury grew up in Concord, went to the old Sun-drop bottle-cap-admission children's matinees at local movie theaters, attended R. Brown McAllister Elementary School, and graduated from Concord High School, so his interest in Concord's history is genuine, based on actual participation throughout much of his life.

As a member of Historic Cabarrus's board, I have seen Michael at work. I make no apology for all the good things I have written about him here, as I and the other board members know what success we have had through his efforts.

Thank you, Michael, for this photographic scrapbook of our wonderful city.

—Helen Arthur-Cornett

ACKNOWLEDGMENTS

The Concord Museum, since its founding in 1939, when the city aldermen of Concord asked that the Coltrane-Harris Chapter of the United Daughters of the Confederacy create a home for area artifacts, has collected hundreds of photographs from newspaper, business, and personal collections. Upon the museum's 2007 merger with Historic Cabarrus, Inc., the collection of photographs has grown by hundreds. Unless otherwise noted, all images in this book appear courtesy of the merged organization, Historic Cabarrus Association, Inc., which I am proud to serve as executive director. Many of these photographs were taken for the *Concord Tribune*, and I must thank the *Independent Tribune*, as the newspaper is now called, for granting permission to publish them.

I wish to thank Helen Arthur-Cornett, Alex Patterson, and George M. Patterson, who generously reviewed my manuscript for accuracy—and extra thank-yous to Helen for penning the foreword and to Alex and George for loaning many of their prized photographs.

I must extend a special thank-you to my editor, Lindsay Carter, for granting me a deadline extension during a family emergency.

Many people provided information, access to special collections, or helped in some other invaluable way: Ray Allen, Mike Blackwelder, Carrell Brooks, Patience Goldston Cochran, Mike Coltrane, Meghan Cooke, Terry Coomes, Patricia Safrit Curl, Maria David, Bernard Davis, Norris Dearmon, Jerry Ervin, John S. Eury, Sue Byrd Eury, Jim Fisher Jr., Frankie Furr, Gene Furr, Joanne Gonnerman, Joe Habina, Clarence E. Horton Jr., Debra Johnson, John King, Vernie King, Lisa Hudson Linker, Butch Little, Bee Manship, Marty McGee, Marta Meares, Barry Moore, Peg Morrison, James Nix, David Olah, Dean Palmer, Alex Porter, Dana Ramseur, Jim Ramseur, Heath Ritchie, Robert Ritchie, Elaine Robb, Rose Rummel-Eury, Dennis Starnes, Jim Summers, Robby Troutman, Hank Utley, Paulette Watson, Cathy Werner, and Anne Wilson.

If I have overlooked any contributor, it was an unfortunate oversight, and I hope you will accept my sincere gratitude for your contributions.

INTRODUCTION

Despite being the home of North Carolina's two most popular tourist attractions—Concord Mills (the state's largest shopping center) and the Charlotte Motor Speedway—Concord remains, at heart, a small town of traditional values. Cradled within the sweeping hills of the lush Piedmont, the city is considered by many to be "God's Country." While other verdant regions might also lay claim to that title, the omnipresence of church steeples punctuating Concord gives testament to the spiritual foundation upon which this community was built.

Seeking religious freedom, German and Scotch-Irish settlers established roots in what would become the Concord area beginning in the mid-1700s. The region made history on May 2, 1771, when nine local young patriots with soot-camouflaged faces (today renowned as the "Cabarrus Black Boys") made what was perhaps the nation's first strike against the British Crown.

Near the end of the 18th century, a new county—Cabarrus, named after Stephen Cabarrus, a French immigrant who helped resolve disputes among the colonists as the state's eloquent speaker of the House of Commons—was formed after these pioneers broke off from Mecklenberg County. Cabarrus once again turned local discord into concord when the statesman appealed to the founders to find a compromise in the selection of their county seat.

In April of 1796, 26 acres of land between Three Mile Branch and the Indian Trading Path became the city of Concord, also called "Conkord" or "Concord Town" in some early documents. Three years later, not far away from Concord in the Midland area of Cabarrus County, the first-documented gold discovery in the United States occurred at what today is known as Reed Gold Mine.

Cotton grew robustly in western Cabarrus County's blackjack soil, pointing Concord beyond its agricultural base toward its first industry: textiles. The city's original textile mill, the Concord Cotton Factory, began operation in 1839 just north of the city limits in what became known in 1887 as the township of Forest Hill (Forest Hill incorporated into Concord two years later). From this plant, known at this writing as the residential/business-hybrid Locke Mill Plaza, blossomed one of the city's cherished hallmarks, the stately Victorian homes of North Union Street that lead into downtown. Nestled under the shade of a canopy of elm and oak trees, these houses remain vibrant today on what is one of the most beautiful streets in the South.

The next boon to the burgeoning city was the railroad, built in the early 1850s on the west side of Concord, on what became known as Depot Street (now Cabarrus Avenue). Cotton and cloth products could now be easily transported into and out of town.

Between 1861 and 1865, the Civil War temporarily slowed Concord's business growth, but after a short occupation by U.S. forces during Reconstruction, textiles once again began to thrive. By the late 1800s, entrepreneurs such as John M. Odell, James W. Cannon, and Warren C. Coleman became wealthy as mills mushroomed throughout the city. Textiles' prosperity illuminated the city's streets and homes in 1888 when Concord's first electrical system was switched on. Also that year, the Concord National Bank was established with Confederate veteran Daniel Branson Coltrane as its secretary-treasurer.

Coltrane's son Lester D. Coltrane Sr., an assistant cashier in the bank, started the Concord Telephone Company in 1897 as an alternative to the Bell Company from nearby Charlotte, which had introduced telephone service to the city two years earlier. With four generations of Coltranes at the helm, the Concord Telephone Company provided telecommunications to several counties until it was acquired by Windstream Communications in 2007.

The streets of downtown Concord of the late 1800s and early 1900s were unpaved, soiled, and boisterous, with a trolley line carting commuters and shoppers to their destinations. Soon, however, the streets were paved, and the downtown area, while consisting of only a few blocks, was dense with activity.

With its utilitarian offerings of the county courthouse, municipal services, banks, a variety of merchants, and entertainment centers, Concord became the nucleus of activity in Cabarrus County. Throughout much of the 20th century, people from smaller nearby communities would "come in to town" to watch courtroom proceedings, fill a prescription at Gibson's Drugs, shop at Belk's, or catch the latest picture at the Cabarrus Theatre.

Concord's population has seen two periods of accelerated growth. The first came in the late 1800s, when the blossoming textile business amplified 1870's total of under 800 residents to 1890's total of 4,000. Slow-but-consistent increases occurred throughout subsequent years, and by the middle decades of the 20th century, the population had settled at a figure of roughly 18,000. Beginning in the 1980s, however, through land annexation, the addition of major employers and the expansion of the motorsports empire surrounding the Charlotte Motor Speedway—which is in Concord, as any local will quickly tell you—the pace of Concord's expansion dramatically quickened. The Concord of 2011 boasts nearly 80,000 residents and encompasses almost 60 square miles—a far cry from the Mayberry-like hamlet whose story unfolds in the photographs on the following pages. Through these images, however, the reader will be reminded that despite these developments, some things really have not changed that much at all.

One

THE MAKING OF A MILL TOWN

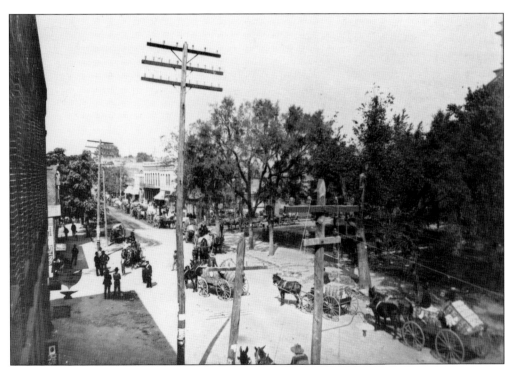

South Union Street in 1898 not only was a gateway into downtown Concord's center of commerce, but it also led to the Odell Manufacturing Company, the massive textile mill at the road's north end. In this bird's-eye perspective from a roof across from the tree-obscured Cabarrus County Courthouse, a bumper crop of cotton is hauled by mule-drawn wagons up the grubby, unpaved road. (Courtesy of the Kannapolis Public Library.)

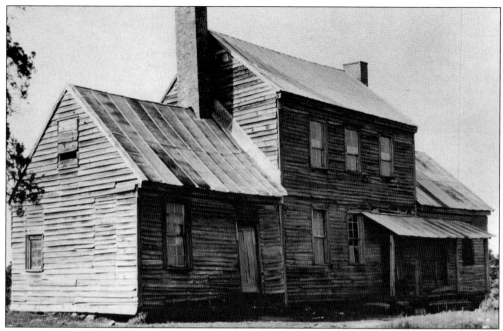

"George Washington slept here" certainly describes Poplar Tent Road's Red Hill, the home and tavern owned by Martin Pheifer (Phifer) Sr. and his two sons. While touring the Southern states, the first U.S. president lodged here on May 29, 1791, as an invited guest of his friend, Martin Jr. The structure was disassembled shortly after this 1970s photograph was taken, but its legend inspired a Concord pub, the George Washington Tavern.

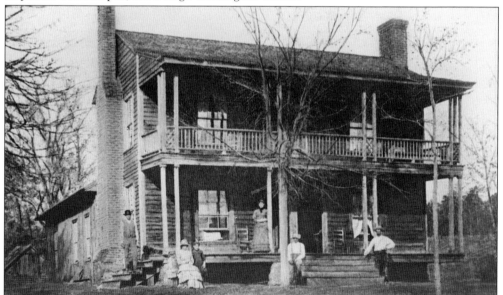

During the mid-1870s, when this photograph of the home of Elias Bost was taken, the Bost family's property on the Rocky River at Concord's south end was a popular site for picnics. Near this home is the Bost Grist Mill, which celebrated its bicentennial in 2010 and remains in operation today, grinding meal products and hosting historical re-enactments. (Courtesy of the Concord Public Library.)

Most Concord houses during the city's early years were modest wooden structures such as the home of D. W. Tucker, built on South Spring Street in 1886. The Sunday-best clothing worn by the men and boys intimates that this photograph may have been taken before or after church.

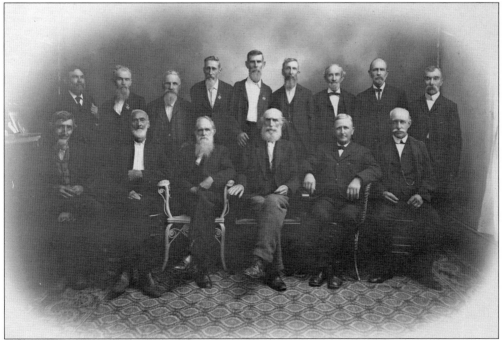

The Cabarrus Rangers, Company F of the 1st North Carolina Cavalry during the War Between the States, fought valiantly under the leadership of Capt. (later Brig. Gen.) Rufus Clay Barringer. This portrait was taken in Concord at a 1904 Rangers reunion. The original photograph is displayed in the Concord Museum, alongside the company's battle guidon.

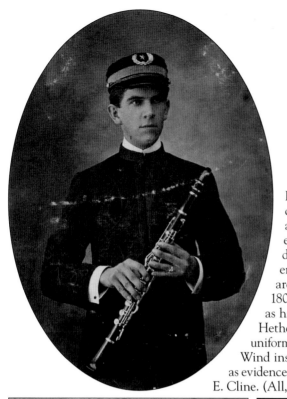

In an era when home entertainment consisted mainly of a family singing around a piano, the Concord String Band engaged concertgoers in town. Under the direction of Robert L. "Bob" Keesler, the ensemble gave its first performance in or around 1870 and performed until the late 1800s. The band's music has long since faded, as has this picture of band member Daniel F. Hethcock (with beard). Wearing a companion uniform is member Will Hall, depicted below, right. Wind instrumentalists were also part of the band, as evidenced by the portrait at left of clarinetist Ralph E. Cline. (All, courtesy of Alex Patterson.)

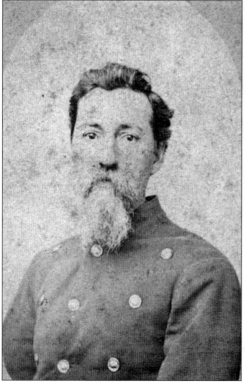

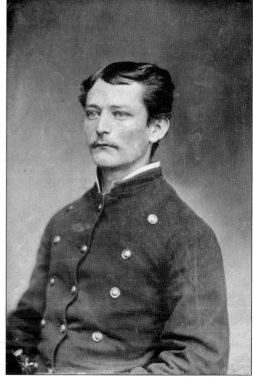

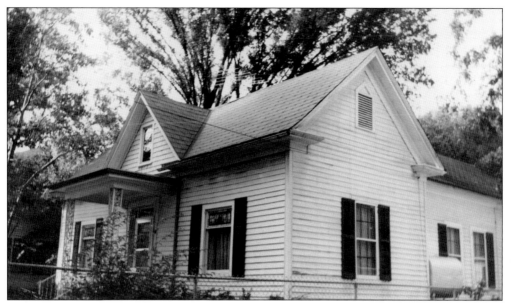

Concord's first medical facility, Concord Hospital (also known as Charity Hospital), began operation in 1891 in four rooms of 84 North Spring Street, a home owned by Brainard Kimmons. A volunteer board of managers consisting of women from various churches oversaw the facility, with physicians R. S. Young and L. M. Archey generously donating their services. It operated for just under a year. (Courtesy of Kenny Propst.)

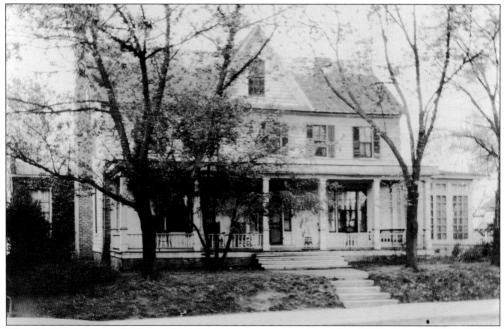

This 1930s photograph shows the Victor Barringer home on North Union Street, where the Concord branch of the Cabarrus County Public Library is located today. On April 18, 1865, fifteen days after the fall of Richmond to Union forces, Confederate president Jefferson Davis spent the night here while en route to Atlanta for refuge. In later years, this home became known as the Houston House. It was demolished in 1971.

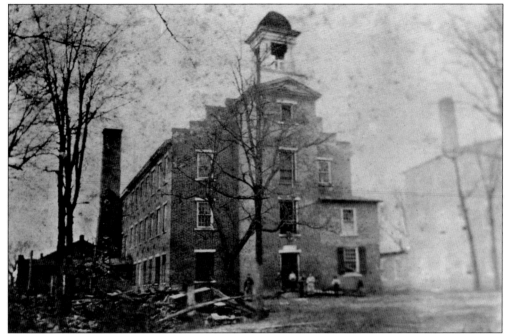

The city's first textile mill, the Concord Cotton Factory, was founded in February 1839 at the corner of Buffalo Avenue and Church Street. It was managed by Gen. Paul Barringer, president, and William Jenks, superintendent. The steam engine that powered the facility was imported from Baltimore, while its spindles came from Fishkill, New York. The factory produced only yarn. (Courtesy of Alex Patterson.)

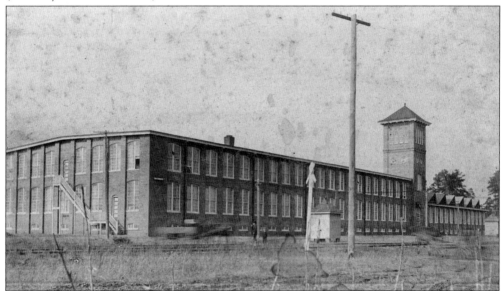

Odell Mills, as seen in the early 1900s, was borne of the Concord Cotton Factory, which John M. Odell purchased in 1877 after the financial panic of 1873 put it out of business. Odell's incendiary financial acumen led to rapid expansions of the plant and ignited the entire community's livelihood. Ironically, the facility went up in flames in August 1908, bankrupting its owner. (Courtesy of Robert E. Burrage.)

No hurdle seemed insurmountable for Capt. John Milton Odell (1831–1910), a former schoolteacher who became the father of Concord's textile industry. His revitalization of Odell Mills spawned the 800-person community of Forest Hill, as well as its own church, Forest Hill Methodist, originally adjacent to the plant. Odell was also a weaver of men's souls: he demanded that his mill managers teach Sunday school at the church.

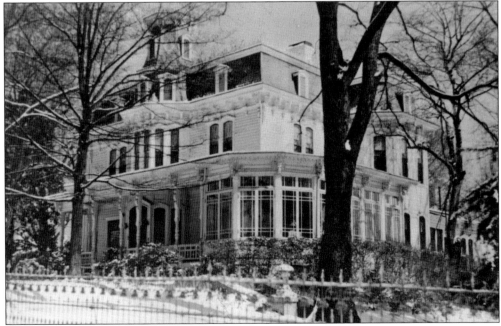

John M. Odell's prosperity allowed him to develop one of Concord's most spectacular residences, at North Union Street and Buffalo Avenue across the street from his mill. Highlights of the home, which was constructed in the late 1860s and early 1870s, include its wraparound porch, prominent central bay, and carriage house. This 1927 photograph was taken several years after the conversion of its side porch into a sunroom. (Courtesy of Alex Patterson.)

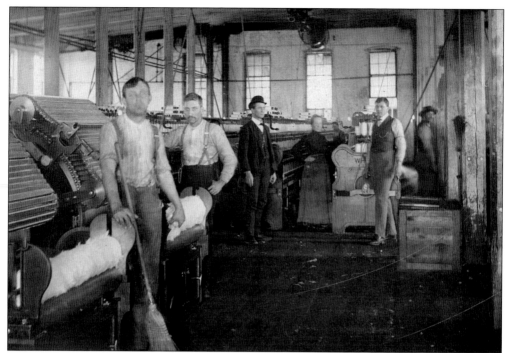

Odell's second textile enterprise was the Buffalo Mill, founded in 1895 on Magnolia Street between Buffalo and St. Johns Avenues. The yarn produced here, seen on the spindles in the background of this photograph, was used at Odell Mills to manufacture its popular "Forest-Hill plaids." In the center-rear of this early-1900s image are, from left to right, B. Luther Still, Emma Mabrey Barringer, and Homer Still. Resembling a band of Wild West frontiersmen, a group of Kerr Bag Manufacturing Company factory workers was corralled for the second picture on this page. In the days before child-labor laws, children often toiled in the mill's sweatshop-like conditions. The Scott Studio took this portrait in 1890, the year the plant was opened by W. H. Kerr.

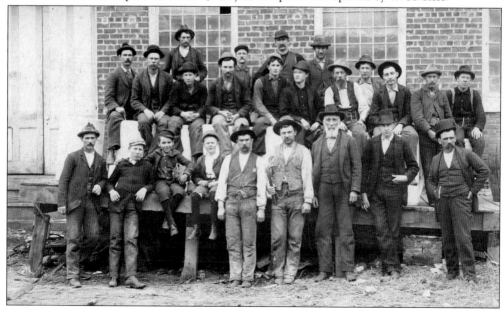

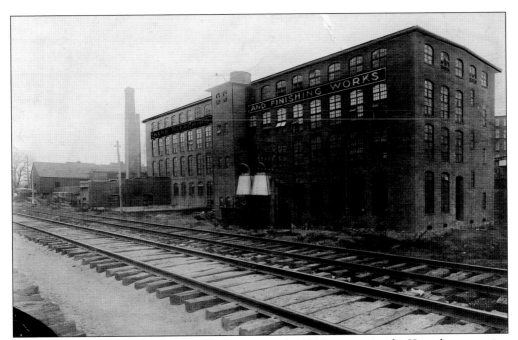

John M. Odell partnered with James W. Cannon in the 1890s to acquire the Kerr plant, creating Kerr Bleaching and Finishing Works, also known as Kerr Bleachery. With the opening of this facility, no longer was Concord-produced cloth shipped north for bleaching or dyeing. This photograph from the late 1890s reveals Kerr's advantageous proximity to the Southern Railway.

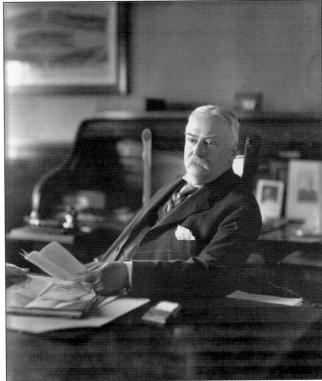

James William Cannon (1852–1921) built his textile dynasty the old-fashioned way, working his way up from the ground floor. As a teenager in 1869, he was first employed as a clerk for his brother, David Franklin Cannon. After business ventures with Concord merchants John W. Wadworth and P. B. Fetzer, Cannon, with partners, opened his first mill, the Cabarrus Cotton Mill, in 1893. (Courtesy of the Kannapolis Public Library.)

19

The shackles of slavery into which Warren Clay Coleman (1849–1904) was born did not deter the young man's post-emancipation mercantile enterprises. A frugal trader and realtor, he operated a general store on South Union Street, where the P. M. Morris Building stands today. By the 1890s, he had become one of North Carolina's wealthiest African Americans. As the textile industry grew in the late 1800s and early 1900s, Coleman imagined a cotton mill owned and operated by blacks, since "colored" workers were primarily limited to menial positions in other mills. Beginning in 1896, he sought funding from both black and white businessmen throughout the state, opening Coleman Manufacturing Company. In 1987, a state highway historical marker was erected in his honor on U.S. 601 Bypass (Warren C. Coleman Boulevard) at Main Street in Concord. (Courtesy of the Kannapolis Public Library.)

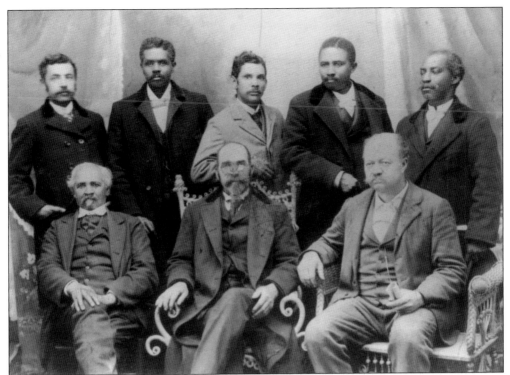

Under the advisement of a board of directors consisting of the state's "black elite" (above), including John C. Dancy, Edward A. Johnson, and James Walker Hood, Coleman Manufacturing Company began producing yarn in 1901 in the west Concord site shown below. At one time employing 300 "colored" workers, the mill fell victim to industry reversals and poor financial management and faced foreclosure in 1904. James W. Cannon purchased and upgraded the facility, which eventually became Cannon Mills Plant 9. (Both, courtesy of Library of Congress, Prints and Photographs Division.)

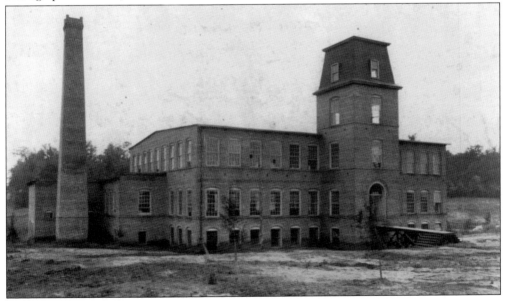

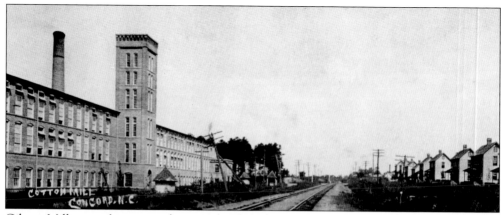

Gibson Mill, seen above in a photograph taken during the early 1900s, was founded in 1899 on McGill Avenue, next to the Southern Railway. The mill houses at the right were part of Gibson Village, a network of homes, shops, and churches that sprouted up in conjunction with the mill. It later became Cannon Mills Plant 6, and today has been refurbished into a popular venue housing the Depot at Gibson Mill Antique Mall, the Auto Barn vintage-car warehouse, and other businesses.

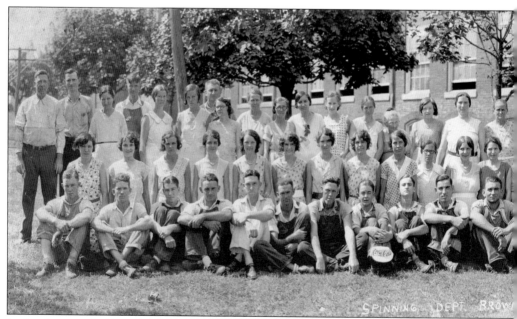

In the photograph above, the Spinning Department of Brown Manufacturing Company assembled for this September 1931 portrait. Located on West Depot Street (Cabarrus Avenue), Brown Mill, as it was commonly called, was founded in 1905 by Charles W. Johnson and Rufus Alexander

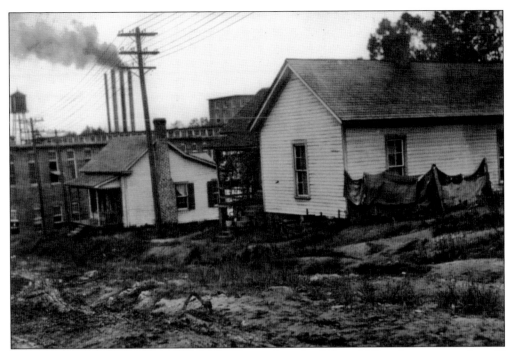

Not all of the earlier Cannon mill houses were as tidy as the Gibson Village homes, or as the mill houses that would later emerge from Cannon. Lewis Wickes Hine was appalled by the ramshackle conditions in the mill houses he photographed in October 1912, adjacent to the Cabarrus Cotton Mill. (Courtesy of Library of Congress, Prints and Photographs Division, National Child Labor Committee Collection.)

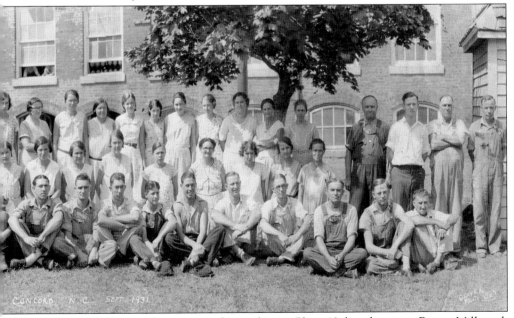

Brown. James W. Cannon later acquired it, making it Plant 10, but the name Brown Mill stuck with locals.

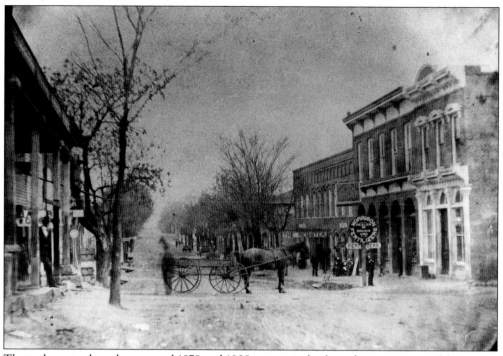

These photographs, taken around 1878 and 1908, respectively, show the progression of downtown from the vantage point of the square, looking south. Trees were bountiful along South Union Street in the late 1870s, but all but one had been removed by the time the second image was made. Both pictures show that horse-drawn wagons and buggies were the principal mode of transportation. In the above photograph, the columned structure in the left foreground is the American Hotel, which was later replaced by the Concord National Bank. The first building to the right is the county jail, and a few doors down is editor John Woodhouse's weekly newspaper, the *Register*. In the lower image, the St. Cloud Hotel is seen in the left foreground. The steeple in the far right background belongs to the 1880 St. James Lutheran Church.

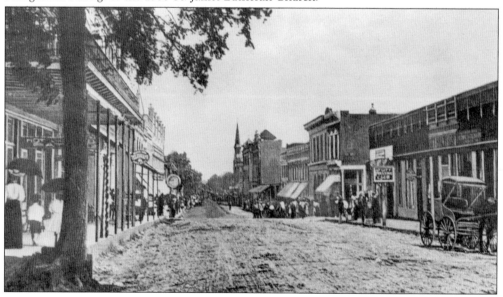

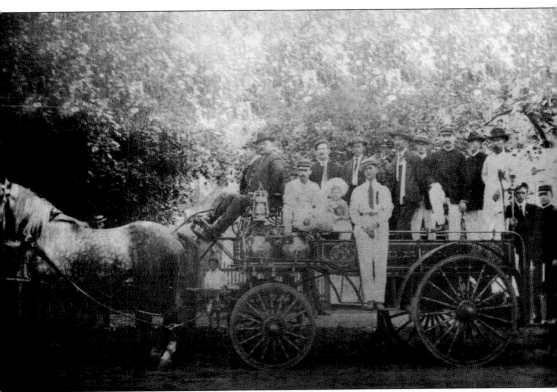

The Concord Fire Department, a group of volunteers operating out of the 1903 Concord City Hall, was established in December 1900, replacing two volunteer organizations: the Concord Hose and Reel Company and the (Colored) Concord Hook and Ladder Company. The man appointed as fire chief was John L. Miller, who held that position for an astounding 52 years. While the quality of this 1908 photograph of the Concord Fire Department is poor, it still speaks volumes about the city's firefighting capabilities during the early 20th century. Seen here is the department's wagon, which raced to the rescue behind two galloping, dapple-grey horses. The wagon's driver, I. T. Biles, was the department's only paid, full-time employee. Seated next to him is Mayor J. B. Caldwell. The youngster in the picture is Dee Ritz, the son of volunteer fireman Henry G. Ritz, also on board. Other firemen shown are J. C. Foil, Shake Willeford, Bob Sappenfield, Bob Wathal, Buck Murr, Frank Carroll, J. W. Propst, Oliver C. Russel, and Ed Isenhour. (Courtesy of the Concord Fire Department.)

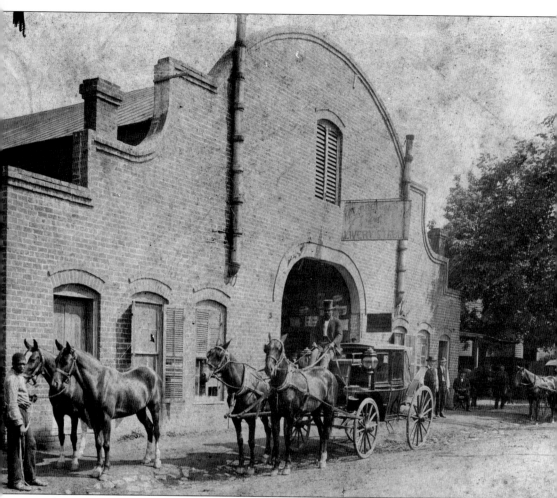

Moses L. and Alfred M. Brown operated M. L. Brown and Brother Livery and Sales Stable from the late 1800s through the 1930s. Headquartered on East Depot Street (Cabarrus Avenue) at the site most recently known as the Fifth Third Bank drive-through, Brown's Stable rented equipment and provided blacksmithing services for horses and mules. Those who remember the stable recall its stench of leather and manure. (Courtesy of Ken Griffin.)

Lester Durrett Coltrane Sr., the father of telecommunications in Concord, brought telephone service to the community beginning in 1897. Initially operating from a back room of the Concord National Bank, Coltrane's Concord Telephone Company's first residential subscribers paid $10 per year for service, while businesses paid $15. By 1899, the company had 140 subscribers.

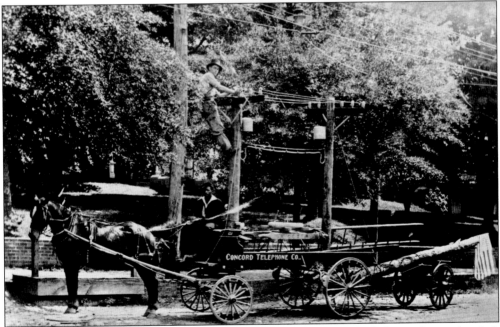

This creative entry from the Concord Telephone Company was a crowd pleaser during the city's Homecoming Parade in September 1916. Lineman Scott Yorke Pharr is the daredevil atop the pole, which includes authentic telephone wires connected to glass insulators. The driver is Ben Allen. This photograph was taken on South Union Street just north of Chestnut Avenue.

The tranquility of Rocky River Springs offers an opportunity for these young picnickers to relax. In a more formal environment, the ladies might have worn festooned bonnets, popular fashion accessories of the day, like the one modeled by Jenn Winslow Coltrane, seen from behind in the 1902 photograph at left. This prize-winning hat was designed by Nannie Lee Alexander. (Left, courtesy of Alex Patterson.)

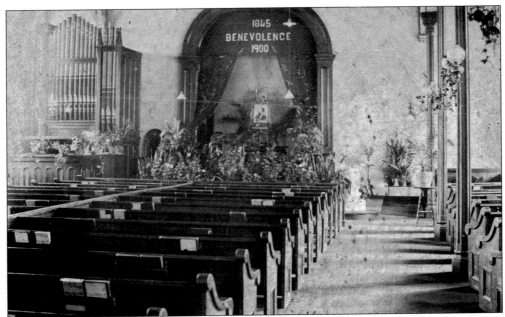

First Presbyterian Church was established in 1804 in a log cabin on the site currently known as Memorial Garden, in downtown Concord on Spring Street. This photograph from 1900, taken inside the sanctuary at First Presbyterian's third location (at the intersection of West Depot and Spring Streets), shows Concord's first pipe organ, purchased in 1880. The church has been located on North Union Street since 1927. (Courtesy of First Presbyterian Church.)

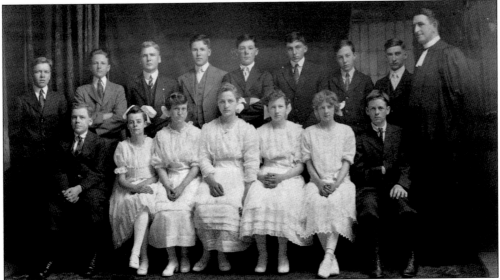

This is a photograph of the March 26, 1916, confirmation class of St. James Lutheran Church. From left to right are (first row) Lynn Erwin Lentz, Mary Young Crowell, Mamie Sappenfield, Katherine Isenhour, Margaret Katherine Graeber, Mabel Dorothea Wolff, and C. Harold Dry; (second row) Charlie Brady Griffin, Clarence Ross Ritchie, William Guy Isenhour, Clifford D. Kluttz, Robert Rufus Isenhour, Marshall Edward Miller, J. William Propst, Charles Blackwelder, and pastor Charles P. MacLaughlin. Many of their families remain members of the congregation today. (Courtesy of St. James Lutheran Church.)

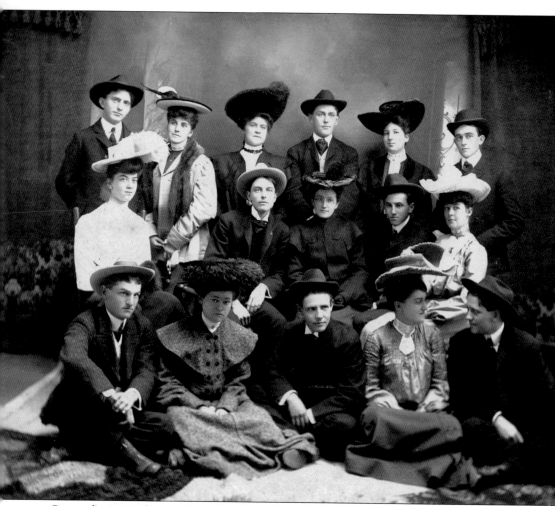

Concord's young elite are dressed to the nines for Charles and Lewis Brown's house party, held during the Christmas season of 1903. From left to right are (seated on floor) Leonard Brown, Jennie Gibson, Lander Grey, and the eye-locked Grace Brown and Noah Carrell; (seated in chairs) Mary Lore, Leonard Boyd, Maude Brown, Lewis Brown, and Irma Kimmons; (standing) Ed Moss, Mary Young, Kate Means, Will Flowe, Chassie Brown, and John Foil. Concord's Orpin's Studio produced this portrait. (Courtesy of George M. Patterson.)

Two

AN ERA OF PROGRESS

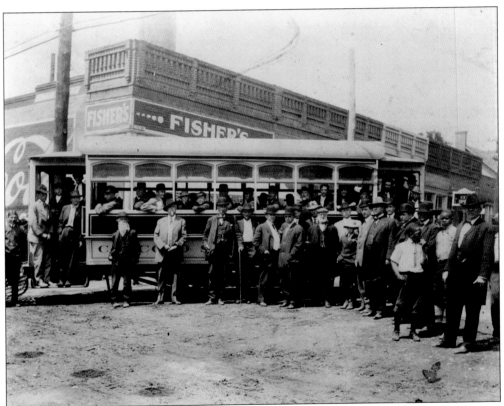

A healthy dose of bravado signaled a new era in the fall of 1910 when the Edison Electric Company's battery-powered streetcar made its inaugural run in downtown Concord, replacing the steam-operated streetcar that had previously chugged along city streets. Mayor C. B. Wagoner was among the day's riders. The streetcar's batteries proved unreliable, and by 1912, the system was upgraded to a traditional electric trolley. (Courtesy of Alex Patterson.)

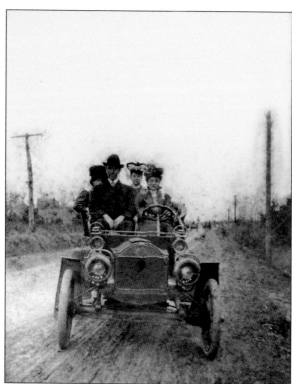

While this photograph from the early 1900s has spotted with age, it illustrates what is reportedly the first automobile in Concord, owned by a Mr. Blume. While little is known about the vehicle or its owner, Blume clearly did not yield to the myth about women being bad drivers. (Courtesy of Alex Patterson.)

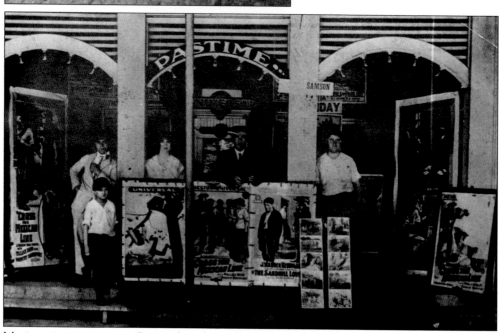

Motion pictures came to Concord in the early 1910s as the Pastime Theatre opened on South Union Street, about midway between Corban and Depot Streets, just south of the square. *Cross the Mexican Line*, a 1914 silent film, was the current attraction in this photograph. William E. Stewart Sr., father of legendary Concord teachers Blanche and Lillian Stewart, operated the movie house.

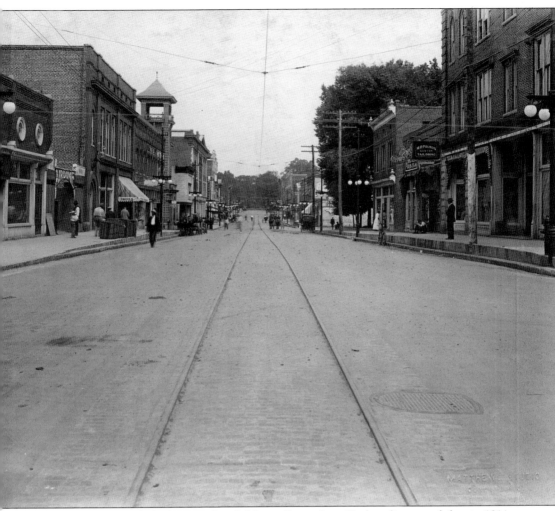

This amazing photograph, looking up South Union Street from Corban Street and shot in 1914 by the Matthews Studio of Concord, illustrates numerous improvements to the downtown. Note that the streets have been macadamized and trolley lines laid. Electric lines to power the trolley crisscross overhead. The four-bulb streetlight system has recently been installed. Along the left side is the Concord Furniture Company, which later became Johnston's. Just above it is the stately 1903 city hall building, which doubled as the fire station. In the right foreground is the Allison Building, which hosted a revolving door of businesses before being demolished in the mid-1970s for the construction of a new Cabarrus County Courthouse. Heading north, the Shoe Hospital's sign is a memorable landmark of the era. Behind the cluster of trees in the right mid-ground is the 1876 courthouse. In this transitional era, both wagons and automobiles shared the road.

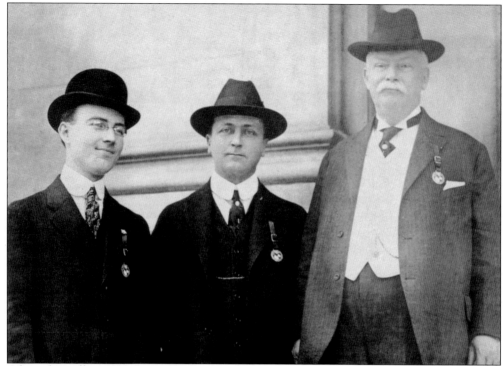

After taking ill in 1921, James W. Cannon (right) placed the youngest of his six sons, Charles Albert Cannon (1892–1971), left, at the helm of Cannon Manufacturing. The junior Cannon sweated out a textile-worker strike and remained at the helm of the company after his father died late that year. This photograph was taken shortly before the senior Cannon became ill. The center figure is unidentified. (Courtesy of the Kannapolis Public Library.)

Ruth Coltrane Cannon (1891–1965), daughter of banker Daniel Branson Coltrane, married Charles A. Cannon in 1912. Ruth was beloved in Concord for her commitment to history and the arts. With the Daughters of the Confederacy, she was a major supporter of the original Concord Museum, which was then called Confederate Memorial Hall. Her preservation passions were not limited to Cabarrus County; she also contributed to the 1959 restoration of New Bern's Tryon Palace.

A sure sign of the region's textile-sparked prosperity was the construction of the stately Cabarrus County Country Club. Built in 1923 in a wooded area off Highway 29 in north Concord, the facility later was destroyed by fire and rebuilt. This 1930s picture was taken by Zack Roberts. (Courtesy of George M. Patterson.)

During the Depression, cigar-puffing Concordian Oscar Blackwelder chiseled out a new career as a talc prospector, shipping his finds in cigar boxes to New York for analysis. A queer black rock he dug up once put him on the radar of the U.S. Department of the Interior—he had discovered a vein of uranium. In this picture postcard, "Mr. Oscar" poses with his beloved blue Essex. (Courtesy of Alex Patterson.)

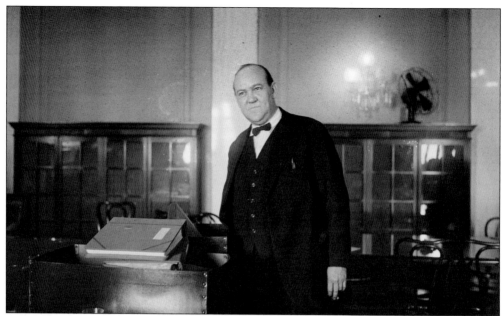

Concord's most duplicitous denizen was, arguably, Gaston B. Means (1879–1938). Conversely, his father, William G. Means, was among Concord's most eminent citizens, being a barrister, mayor (1890–1892), and state senator. Those who met the smooth-talking junior Means might be led to believe that he was a teacher, a traveling salesman, or a private eye. Among his scams, which occurred in several states, was bilking a widow of her savings through a "discovered" will and claiming knowledge of the whereabouts of the kidnapped Lindbergh baby. Means, seen in 1924, was ultimately sentenced to 15 years in federal prison and died behind bars. Also shown is his homestead, at 138 North Union Street. During Means's incarceration, the FBI scoured his home looking for stolen cash, while treasure-happy locals shoveled through the yard at night. (Above, courtesy of the Library of Congress, Prints and Photographs Division, LC-F81-29376.)

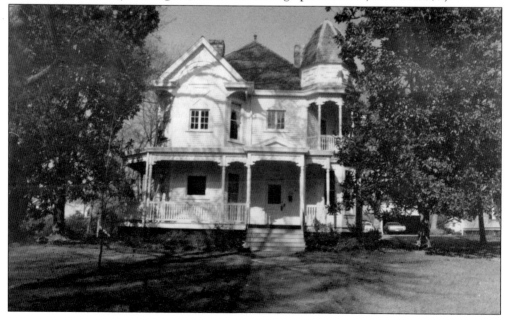

Children growing up in many of the influential white families of the early to mid-20th century were frequently cared for by African American maids or nannies, who in some cases became an extended family member. Since Concord was the home of Barber-Scotia College, a prestigious learning institution for African American women, maids were often well educated and helped teach the youths under their care. In the photograph at right, former slave "Aunt" Emily Bowman Alexander, working as a maid, comically gives young John K. P. Odell a mock "whuppin'." (As an adult, Odell went on to become president of Kerr Bleachery.) Alexander resided in the small shack seen at left of the photograph below, next to the home of her daughter, Mary Alexander Pharr, in Silver Hill, an African American community in Concord. (Both, courtesy of Alex Patterson.)

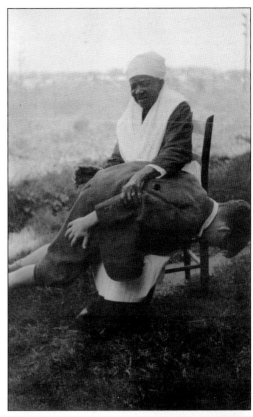

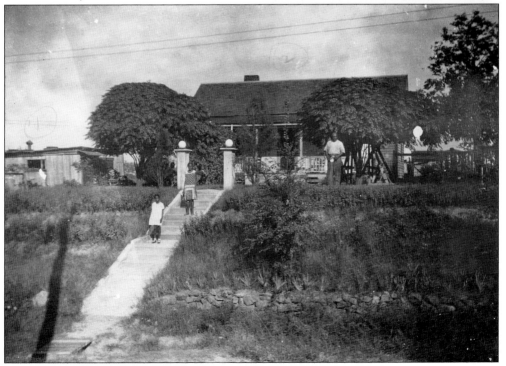

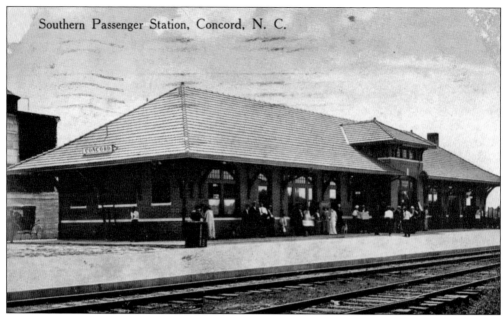

Southern Passenger Station, Concord, N. C.

Adjacent to the Cabarrus Cotton Mill (Plant 5) was Concord's train depot, officially known as the Southern Railway Passenger Station, the city's gateway to and from other communities. This postcard image, photographed in 1925, shows passengers waiting for an incoming train. The office of the Southern Express Company was located inside.

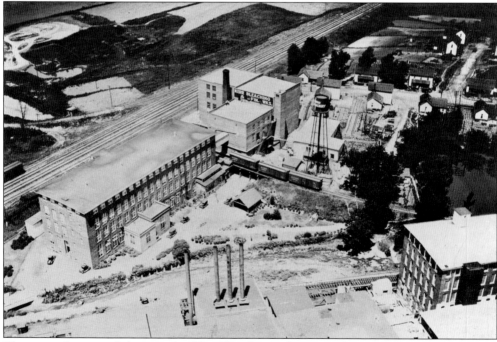

This astonishing aerial photograph of Kerr Bleachery, taken around 1925, illuminates how crucial the Southern Railway line was to Concord's textile industry. In the center of this shot is a loading track installed by Kerr. The water tower trumpets the plant's name, a common practice across town. Note the mill houses in the upper right.

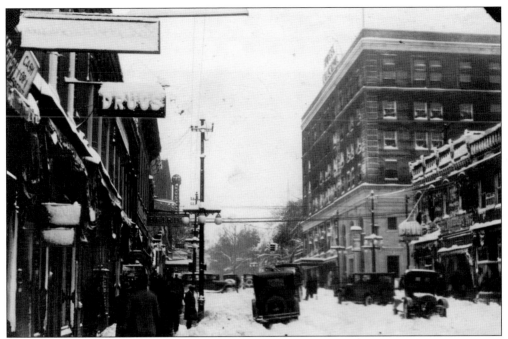

In March 1927, Concord was blanketed by 14 inches of snow as measured by S. Kay Patterson, who kept area meteorological records for the U.S. Weather Bureau. This photograph, originally from a Jackson Training School scrapbook, provides a close-in look at the square, where automobiles comically plow through the winter wonderland. Note the Hotel Concord's sign at the top center of the shot.

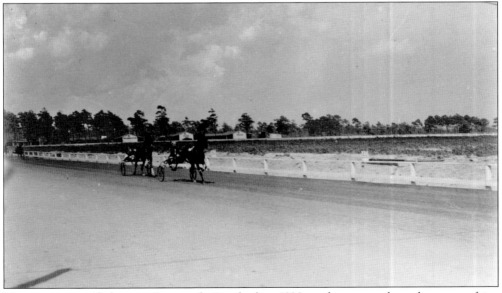

Horse races provided entertainment during the late 1920s and were trendy at the county fairs, held in those days on a large track where West Depot Street (Cabarrus Avenue) met Highway 29, today the home of S&D Coffee. The previous fairgrounds were near downtown Concord between South Union and Spring Streets. Skipper Studios of coastal South Carolina was hired to take this shot. (Courtesy of George M. Patterson.)

This portrait by Concord's Harry A. Deal huddles the 1927 Sunday school classes of McKinnon Presbyterian Church, located on Church Street at McKinnon Avenue. The pastor was R. A. Underwood. The steeple peeking above the trees rises from the church's original 1900 sanctuary; a brick church would be erected in 1934. In 2008, the congregation disbanded after years of declining membership, generously donating $250,000 from its treasury to a county hospice care center.

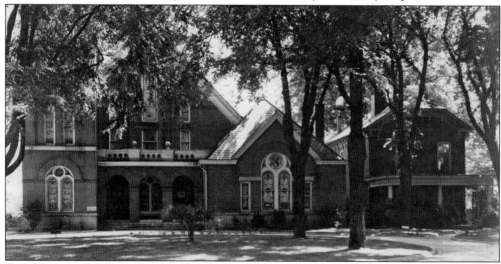

Central (United) Methodist Church, on Union Street just north of the square, was photographed by Zack Roberts in 1939. One hundred years earlier, the congregation began as Concord Methodist Episcopal Church. This structure was made from bricks produced in Mount Pleasant and drudgingly transported by mule, with construction beginning in 1860. This building was demolished in 1972 to make way for Central's current sanctuary.

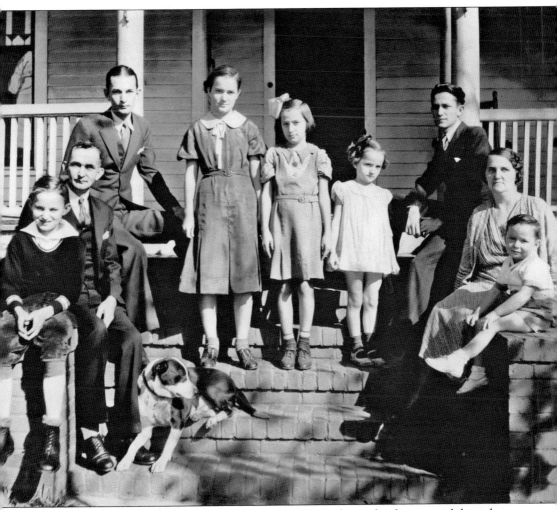

Conservation was the key during the Great Depression, for both people of means and those down on their luck. Families were often large, and everyone pitched in where needed. Many children went to school shoeless, and families' wardrobes were small, with members wearing the same clothing repeatedly before washing. The Fred L. Howell Sr. family, on the front steps of their 274 North Spring Street home in the Forest Hill area, was a typical Concord family during the 1930s. When Howell lost his job as a machinist at Locke (formerly Odell) Mill, he opened his own machine shop and through perseverance became a success. His youngest child, Rod (far right), went on to become a physician and as of this writing serves as senior advisor to the director of the Eunice Kennedy Shriver National Institute of Child Health and Human Development of the National Institutes of Health. (Courtesy of Rodney Howell, M.D.)

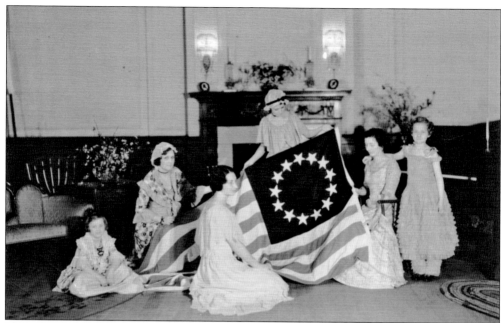

The economic turmoil of the Depression did not deter Concord's cultural scene. On Tuesday, March 31, 1932, the pageant-play *The Beginning of the Art-Song in America*, written by Janie Patterson Wagoner, was presented in the Hotel Concord ballroom. The event was sponsored by the local chapter of the Daughters of the American Revolution. Directed by Mrs. E. Ray King, *Art-Song* included *The Birth of the Flag*, recreating the story of Betsy Ross's sewing of the first American flag, as seen in the photograph above. From left to right are Nancy Sims Ridenhour, Frances Ridenhour White, Margaret Virginia Ervin (as Betsy Ross), Fay Polk Fisher, Elizabeth Harris Northrup, and Mary Iris Goodman. The picture below spotlights the assembled cast. These portraits were photographed by M. L. Philmon of Charlotte. (Both, courtesy of Alex Patterson.)

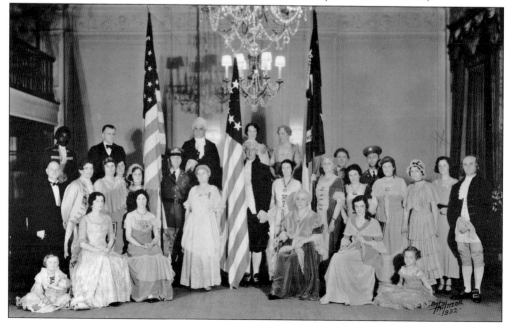

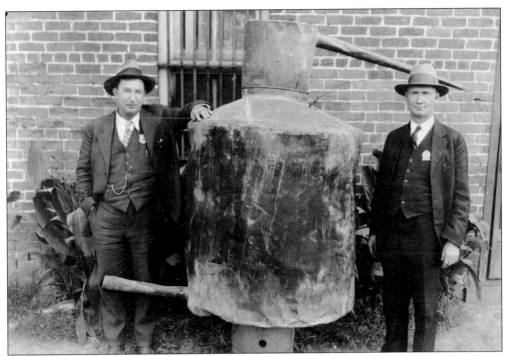

Daniel F. Widenhouse (right) of East Depot Street busted stills in Cabarrus, Rowan, and Stanly Counties as a U.S. federal agent. Widenhouse developed uncanny tracking skills while ferreting out moonshiners and was no stranger to climbing trees or wading through creeks searching for giveaways such as a still's blue smoke. His partner is an unidentified agent from the tri-county region. (Courtesy of Tonya Rosman and Sherie Jenkins.)

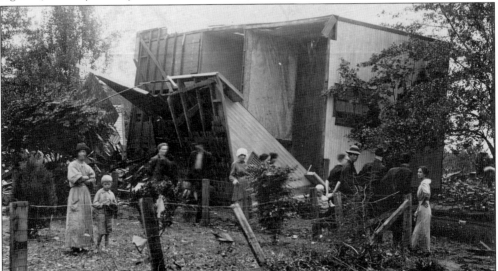

In 1936, a cyclone ripped through Concord, peeling off roofs and toppling small homes, as seen in this photograph taken by insurance agent John K. Patterson. Perhaps the most remembered damage from the tornado happened on North Union Street when First Presbyterian Church's steeple was yanked from its perch, ricocheting off the fence of the E. T. Cannon home next door before burrowing into the churchyard. (Courtesy of Alex Patterson.)

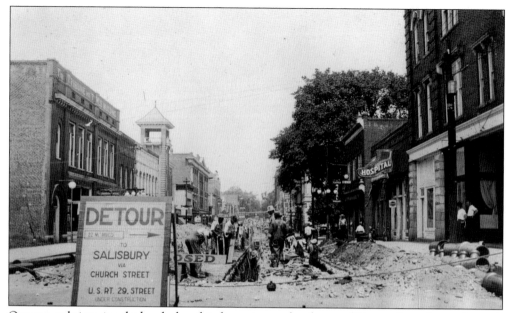

One can only imagine the headaches this disruptive roadwork caused Concordians during the mid-1930s. This photograph looks north onto Union Street from the Corban Street intersection. The detour sign in the foreground is a reminder that during these pre-interstate days, Concord's main streets doubled as highways. (Photograph by Zack Roberts; courtesy of George M. Patterson.)

Some folks no doubt did a double take on this day in the late 1930s when Johnston's Furniture Store, located on South Union Street at the corner of Barbrick Avenue, promoted their new linoleum pattern by stretching it along the sidewalk. (Photograph by Zack Roberts; courtesy of George M. Patterson.)

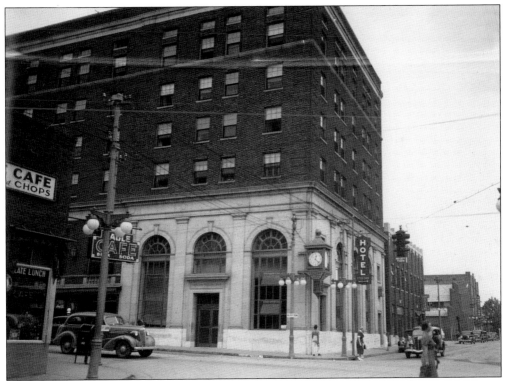

In the late 1930s, Zack Roberts took advantage of a lull in downtown Concord's activity to snap this photograph of an uncharacteristically quiet square from West Depot Street. The Concord National Bank, whose facade remains uncannily similar today, is the picture's focal point. Directly behind the bank down Depot Street is the office of the Concord Telephone Company. (Courtesy of George M. Patterson.)

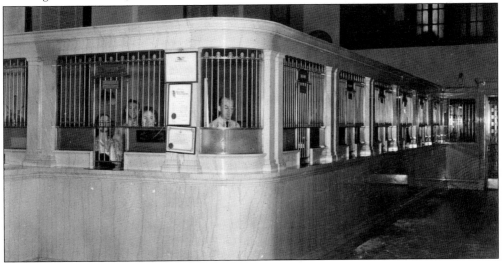

In 1938, Citizens National Bank was located at 26 South Union Street, where the City of Concord's offices are today. Clyde L. Propst Sr. is counting currency at the corner-front station near the center of this picture. At the left, smiling graciously for photographer Zack Roberts, are, from left to right, an unidentified teller, Boyd Biggers, and Nancy Allred. (Courtesy of George M. Patterson.)

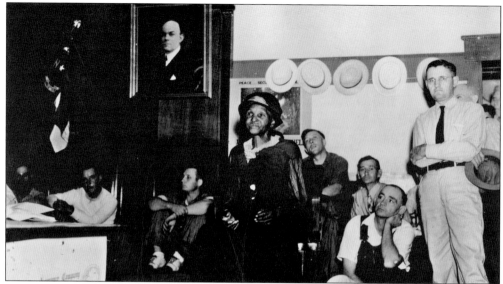

Long before television, the courthouse provided entertainment as crowds were attracted by sensational trials, such as the July 1938 murder trial of Baxter Parnell, accused of killing his sister-in-law. The defendant claimed that he was driven into a homicidal frenzy by herbs given to him by "Aunt Jewl" Morris, seen here on the witness stand. (Photograph by Zack Roberts; courtesy of George M. Patterson.)

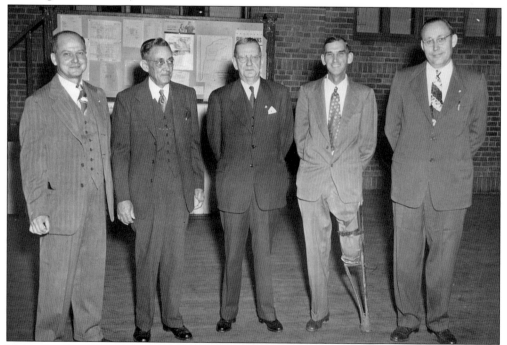

Virtually every region around Concord boasted at least one active textile mill. Superintendents from several of the area's plants gathered for this late-1930s photograph. From left to right are Charles S. "Sam" Dorton, Brown Mill; unidentified, White Park; Harvey Moore, owner of Brown, Roberta, and White Park Mills; Zeb Cochran, Roberta Mills; and unidentified. Cochran lost his leg in a mill accident. (Courtesy of Charles and Naomi Dorton.)

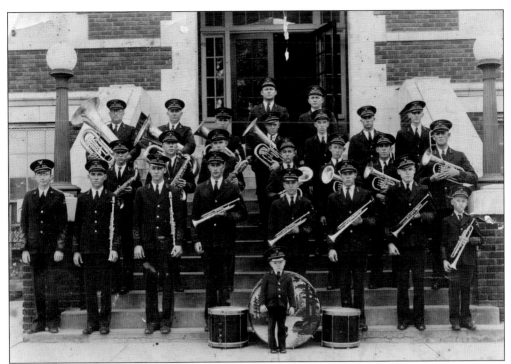

Working in the mills also provided a sense of identity that extended into after-hours activities, with many plants sponsoring performance groups and athletic teams. This tattered photograph shows the Franklin Mill Band of the late 1920s; Franklin Mill was originally the Coleman Manufacturing Company and later Cannon Plant 9. Its musicians are not specifically identified, but some names from the Franklin Band roster of the day include Ervin Christenbury, Charlie Dobbs, Rayfield Dunn, Pink Humberger, Bobby King, Charlie Medlin, J. W. Talbert, Bennie Wade, J. W. Wade, Leonard Wade, and Carl Williams. The photograph below, by Zack Roberts, shows Gibson Mills's baseball team of the late 1930s, taken at a playing field near the plant's McGill Avenue location. (Above, courtesy of Charles and Naomi Dorton; below, courtesy of George M. Patterson.)

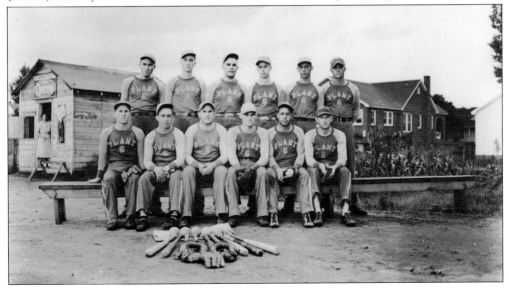

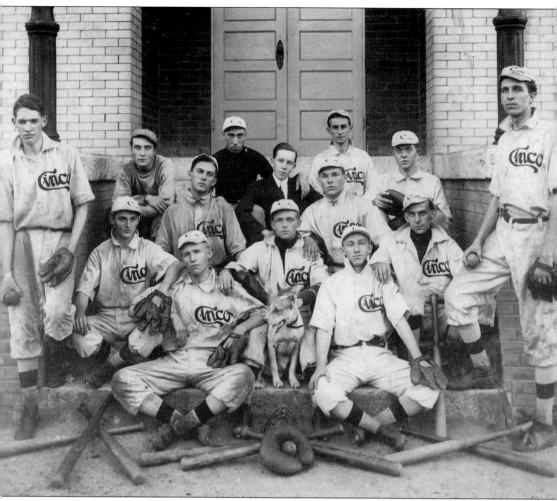

During the 1920s and 1930s, baseball became America's national pastime. In mill towns like Concord, it provided a means of escape from a life that demanded much and offered little. Semipro teams formed, such as the Concord Weavers and their archrivals, the Kannapolis Towelers. The photograph on this page shows the Cinco team from the early 1930s. They borrowed their team name from Cinco Cigars, and their uniforms were donated by Concord merchant A. Jones Yorke. From left to right are (first row) infielder ? Wood and outfielder ? Cook; (second row) third-baseman O. Sappenfield, catcher Fred Patterson, shortstop L. Sappenfield, outfielder ? Wadsworth, and infielder ? Barrier; (third row) outfielder ? Dusenberry, pitcher ? Clark, manager ? Bell, outfielder ? Bingham, and first-baseman ? Greer; (standing) pitchers ? Bell and Campbell Cline. (Courtesy of Alex Patterson.)

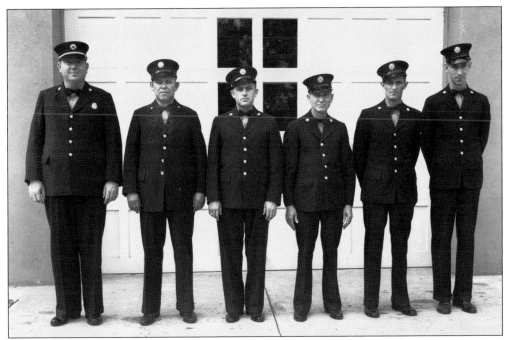

Memories of the Concord Fire Department's horse-drawn wagon had mostly wafted away by the time these mid-1930s firemen, now motorized in their firefighting, assembled for this portrait by Zack Roberts. From left to right are Sam Foil, Charles Miller, Carol Stinson, Jake Talbert, Joe Misenheimer Sr., and Earl Freeze. (Courtesy of the Concord Public Library.)

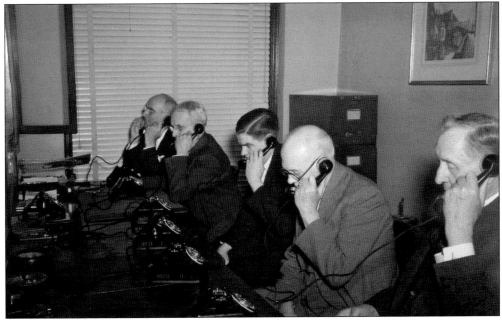

Originally, Concord Telephone Company customers relied on an operator to connect them to their numbers. The company upgraded to a dial system in April 1940; placing the first calls on the new system were, from left to right, Charles A. Cannon, L. D. Coltrane Sr., Theodore M. Schramm, Mayor W. A. Wilkinson, and Dr. W. C. Houston. (Courtesy of the Concord Public Library.)

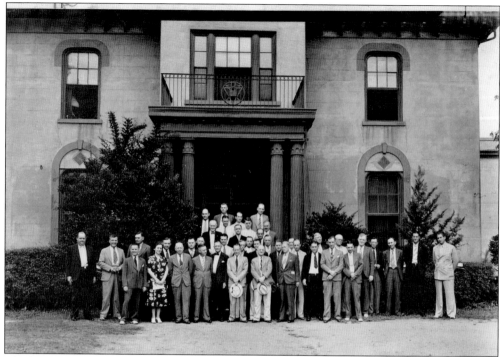

The brick-and-stucco "Sandy" Smith house was built in approximately 1868 at the corner of North Union Street and Holly Lane (now Killarney Avenue). At one time, it was encircled by a fence to deter wandering livestock from grazing. It was also the site of Concord's first sidewalk, built by Smith himself. Members of the Concord Rotary Club pose before the building in this late-1930s picture by Zack Roberts. (Courtesy of George M. Patterson.)

Architect A. G. Odell Jr. remodeled the "Sandy" Smith house into the Concord Community Center in 1940 thanks to funds from the Works Progress Administration. It was the home of the Concord Public Library, (Confederate) Memorial Hall (which continues today as the Concord Museum), and a YMCA swimming pool (behind the building). The center was torn down in June 1977 when the library's new location was opened across the street.

One of the city's treasures is the Cabarrus County history mural, painted by James McLean and measuring an impressive 52 feet across and 12 feet high. It was unveiled in a formal ceremony at Memorial Hall on March 21, 1941, with guests including North Carolina governor Clyde R. Hoey. In this photograph, McLean is standing, wearing a carnation. The mural's current home is the auditorium of Concord's library.

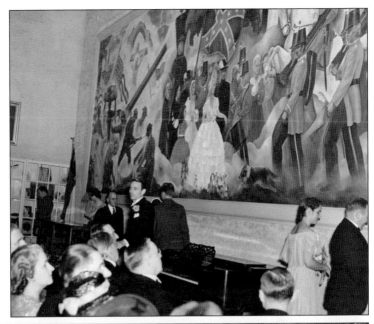

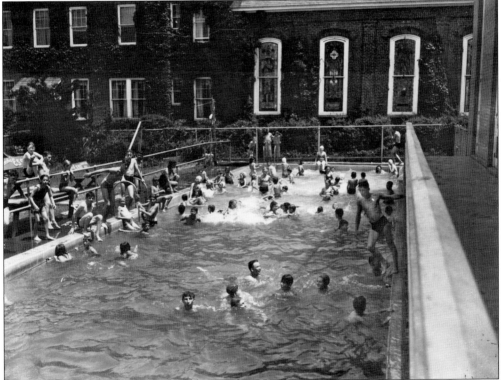

From the 1940s through the 1960s, the coolest spot in Concord was the YMCA swimming pool, sandwiched between the Community Center in the front, Fire Station No. 1 in the back, and Central Methodist Church from the side. Bordering buildings meant little to the carefree kids splashing about, however. Concord educator John McInnis supervised aquatic activities at the "Y" for years. (Courtesy of the Concord Public Library.)

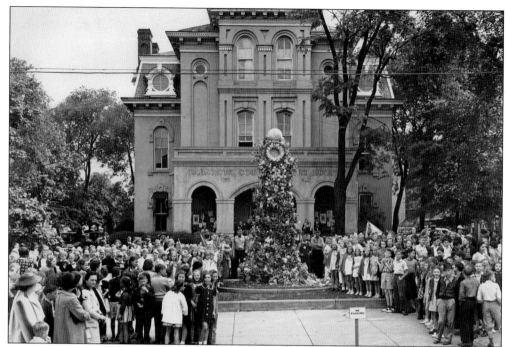

Concord's celebration of Confederate Memorial Day, occurring each May, begins with the United Daughters of the Confederacy adorning the 16-foot Confederate monument with flowers and flags. Field trips of children from neighborhood schools would arrive at the courthouse to honor local soldiers who died during the Civil War. This photograph from the 1930s only hints at the attendance totals for the event. The remembrance continues to this day, although the schools no longer participate.

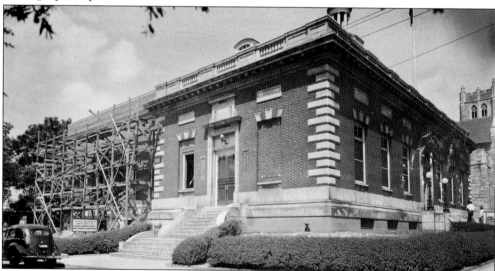

Federal funding allowed for the expansion of the Concord Post Office in 1940. Built in 1912, the post office was located on South Union Street. It neighbored the 1928 St. James Lutheran Church, seen in the right background. Celebrated architect Edwin Phillips subtly converged Tudor Gothic and art deco styles with his design of St. James, which remains one of Concord's most spectacular church buildings. (Courtesy of Alex Patterson.)

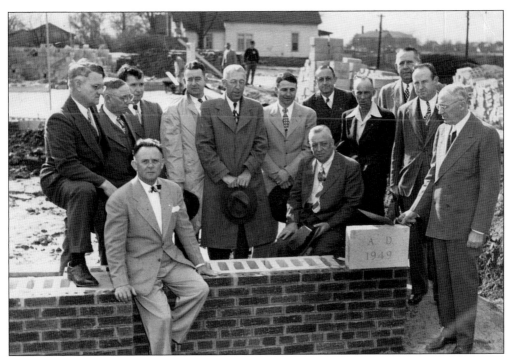

Dr. T. N. Spencer spearheaded a fund-raising campaign to build a place where area boys could congregate for athletics and fellowship, and in 1940, the cornerstone was laid on North Spring Street for the Cabarrus County Boys Club. James Babb captured the project's organizers in this photograph. From left to right are (seated) Robert Ridenhour and E. K. Willis; (standing) Patt Ritchie, Lee White, Boys Club executive director Donald Sams, Dr. Fred Craven, Reverend Hamilton, Martin Lafferty, Ray Cline, Bill Waterfield, Robert Sasser, Conrad Hill, and Dr. Spencer. A local lake-oriented recreational facility was later named in the doctor's honor: Camp Spencer. The photograph below shows the completed Boys Club structure, with its iconic keystone sign. (Both, courtesy of the Cabarrus County Boys and Girls Club.)

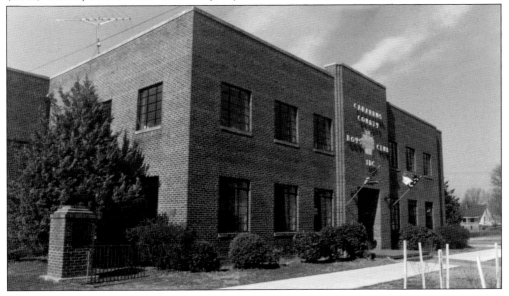

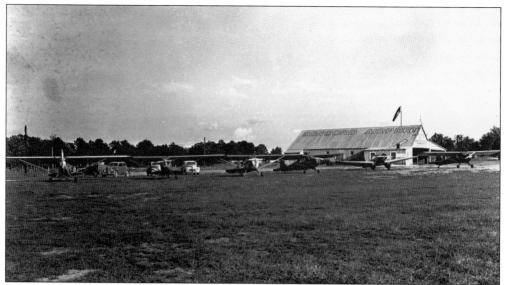

The Concord Airport, located on Cold Springs Road across from Pounds Lake, was operated by Lewis Whitley from the late 1930s through the 1940s and accommodated single-engine planes. The airport occasionally sponsored air shows and skydiving displays, to the great amusement of locals. (Courtesy of the Concord Public Library.)

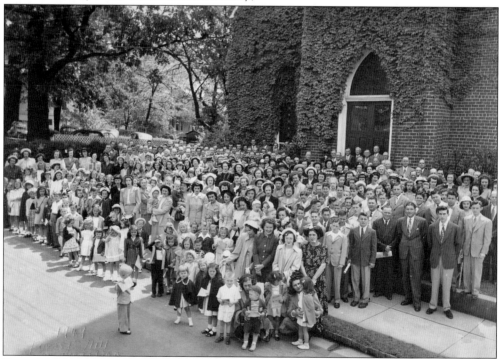

Forest Hill Methodist Church's congregation flocked together on Mother's Day 1949 for this shot taken from an elevated position on Buffalo Avenue. The fence in the left background is no longer there, having been replaced by the parking lot of the church's new sanctuary, which opened around the corner on North Union Street in 1987. The old sanctuary remains in use for special services. (Courtesy of Forest Hill United Methodist Church.)

Three

THE HOME FRONT

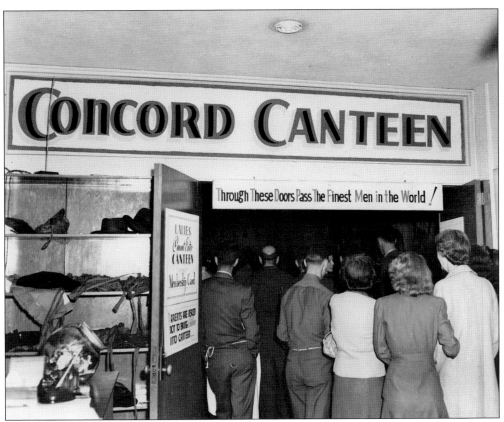

While U.S. servicemen and servicewomen battled the Axis threat thousands of miles away during World War II, the people of Concord contributed to the war effort through unwavering support for the military. The Concord Canteen, a temporarily rechristened Memorial Hall, kindly opened its doors to host parties for soldiers home on leave. Lodging was provided nearby at the armory, and families prepared meals for soldiers.

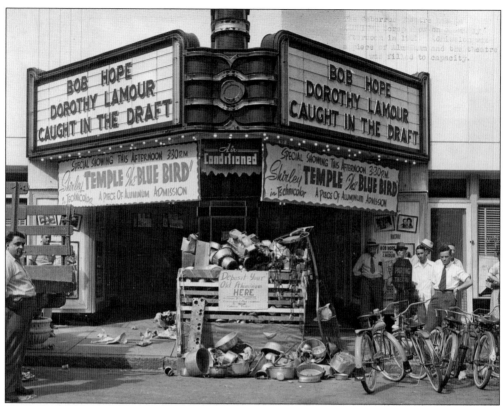

During the war, American communities were urged to collect resources such as aluminum and rubber that could be recycled into weapons and other tools to benefit the Allied forces. In this first photograph, the Cabarrus Theatre in downtown Concord waived its fees, charging instead one piece of aluminum as admission. Its presentation was an afternoon matinee of a Shirley Temple comedy, *The Blue Bird*. In the photograph below, three local civic organizations pooled their resources to open this war bonds booth, positioned between the Cabarrus Theatre and its next-door neighbor, the Cannon Building.

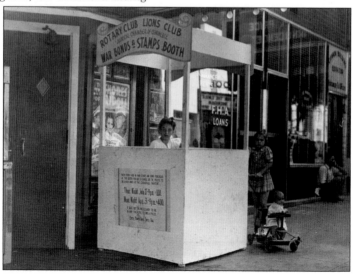

This gag photograph, taken by Zack Roberts at the Concord square, shows Tom Stilwell receiving a mock ticket from Concord policeman Walter E. Bonds, grandfather of retired North Carolina State Bureau of Investigation special agent Bobby R. Bonds. Observing in the background is G. T. Barnhardt, father of former North Carolina lieutenant governor Luther Barnhardt. (Courtesy of Bobby Bonds.)

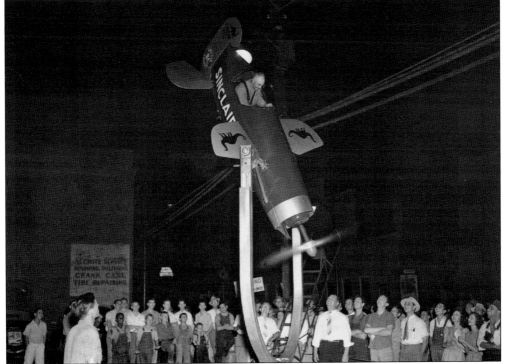

The Barefoot Oil Company raised money for the war effort by importing this mobile flight simulator and selling rides. One wonders how many of the mesmerized observers seen here mustered the courage to climb aboard. The simulator is emblazoned with logos from Sinclair, the petroleum that Barefoot Oil Company marketed. (Courtesy of the Concord Public Library.)

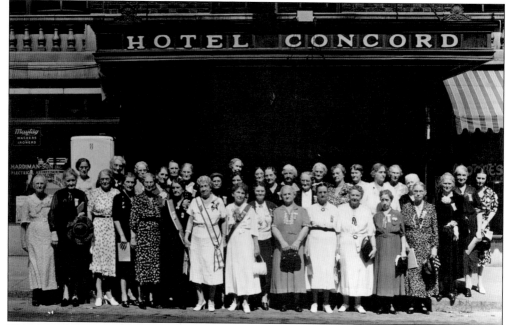

The American War Mothers, founded in 1917, held its 1942 State Convention of the North Carolina War Mothers in Concord, with Frances F. Ridenhour as state president. Many of the attendees gathered on North Union Street for this photograph in front of the Hotel Concord. While it has changed its awnings and signage numerous times since opening in 1925, the hotel's facade remains essentially the same today.

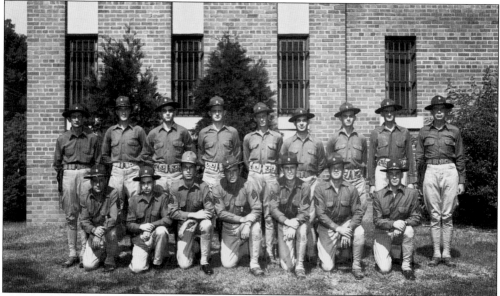

A collaboration between the City of Concord and the Works Progress Administration in 1936 and 1937 led to the construction of Concord's North Carolina National Guard Armory on North Church Street near Edgewood Avenue. This Zack Roberts photograph depicts members of the guard in front of the building. At this writing, the armory is used as a sports-training facility. (Courtesy of the Concord Public Library.)

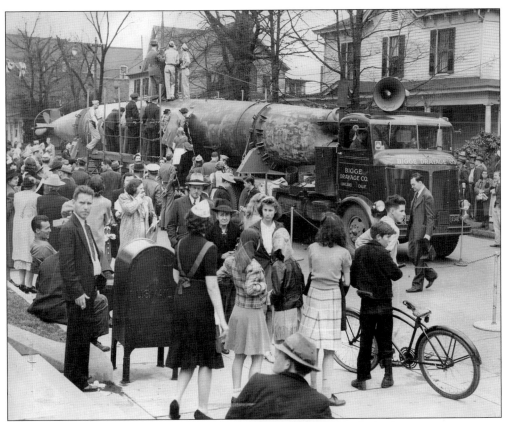

On a winter day in 1943, a captured Japanese "midget" submarine was trotted out for Concord citizens to see, as a sales incentive for war bonds. In the exterior image, shot catty-cornered from North Union Street facing south, the Houston House is visible across the street. There was such a commotion to view this oddity that the submarine and the vehicle towing it were chained off, with directed access only. Additionally, photographer Zack Roberts took a rarely seen interior shot of the sub. These images were appropriated from a Jackson Training School scrapbook.

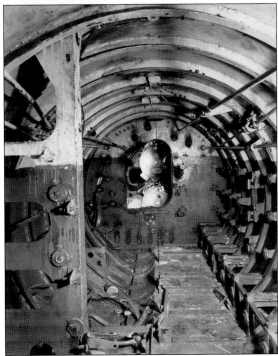

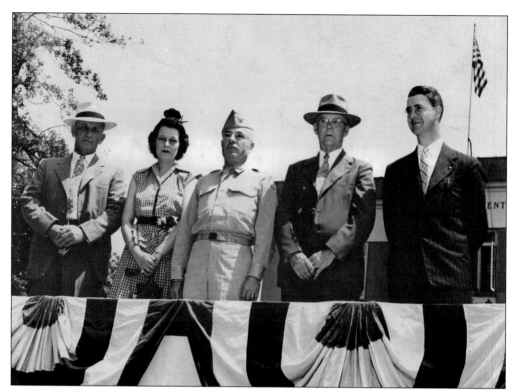

On Wednesday, May 19, 1944, a parade through the streets of downtown Concord honored 900 participating soldiers who were members of the U.S. Army Corps of Engineers. From left to right on the viewing stand are L. D. Coltrane Jr., Concord Canteen committee-member Mrs. A. (Jones) Yorke, Camp Sutton (Monroe, North Carolina) commander Col. Paul Ellman, Concord mayor W. A. Wilkinson, and canteen official Dave Austell. In the photograph below, the Concord High School marching band lobbies for war bonds in a Concord Christmas Parade of 1943 or 1944. (Below, courtesy of Jimmy Auten.)

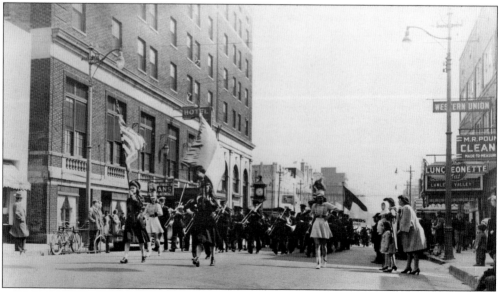

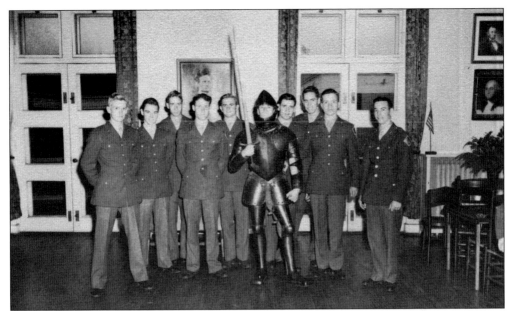

Inside the Concord Canteen (Memorial Hall), a serviceman dons the hall's replica suit of armor, which originally hailed from the collection of E. T. Cannon, and poses with other soldiers who are home on leave. Cannon generously dedicated the battle suit to the hall in the early 1940s. The armor, since refurbished, can be viewed today at the Concord Museum. (Courtesy of Martha Summers.)

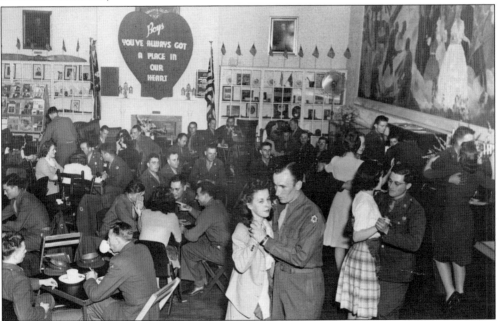

Since the War Between the States, the women of Concord have provided support for the men who have left home to serve their country, as evidenced by the heart-shaped sign hanging in the background. Local ladies during World War II were the organizers of Concord Canteen events. This dance in Memorial Hall allowed servicemen the opportunity to put the war behind them for a few hours.

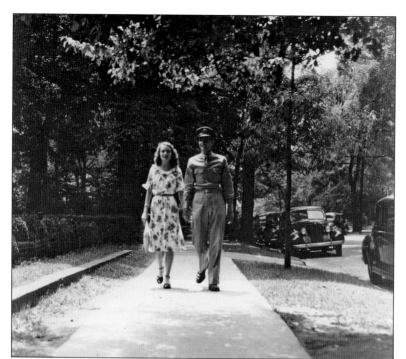

In a Zack Roberts photograph that might have easily doubled as a Norman Rockwell painting, a North Union Street stroll provides a respite from the war's bloodshed for this unidentified soldier and his lady friend.

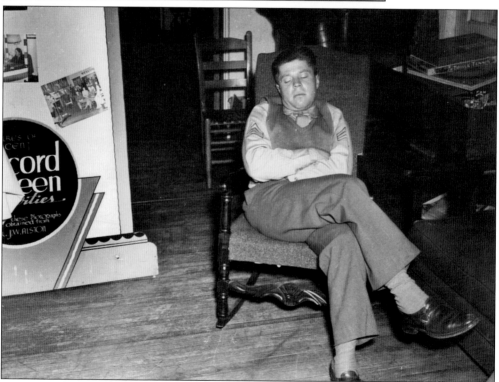

This snoozing sergeant found the evening's activities at the Concord Canteen more than he could handle. Curiously, while this unforgettable photograph taken by Zack Roberts appeared on the cover of the March 25, 1944, edition of *The State* magazine, this serviceman remains unidentified.

Four

CONCORD SCHOOLS

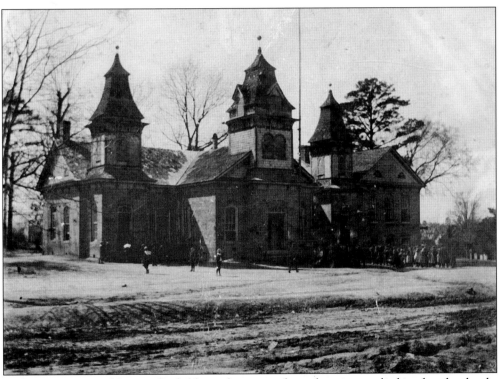

In the 1800s, most of Concord's children who received an education studied in church schools, while families of means educated their children by hiring tutors or enrolling them in private academies. The city of Concord voted by a narrow margin in 1891 to establish public schools. The first was held in this building, the former Concord Female Academy, which was established in 1887.

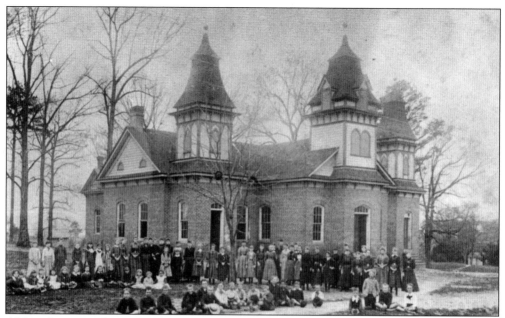

Although grainy, this 1890s photograph offers a closer look at the Concord Female Academy, with its students of different grades assembled. It was located on a wooded lot at the corner of Spring Street and Grove Avenue, on the site where Coltrane-Webb Elementary is today. The uninitiated might have mistaken this for a church, given its piercing towers and chiming of a rope-pulled bell to call students to class.

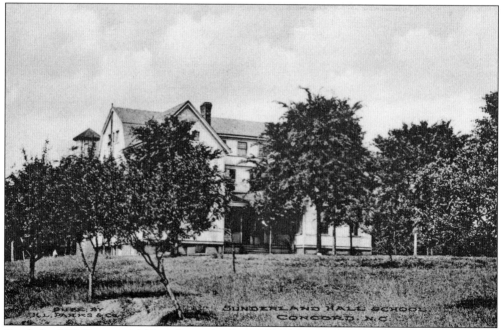

Sunderland Hall was a girls' boarding school on Old Charlotte Road, built in the 1890s on the property of the late George M. Lore. After Concord's Presbyterian academy, White Hall, was destroyed by fire, Sunderland Hall acquired many of its students. It operated for just over two decades and is seen here in a picture postcard from around 1910. (Courtesy of the author.)

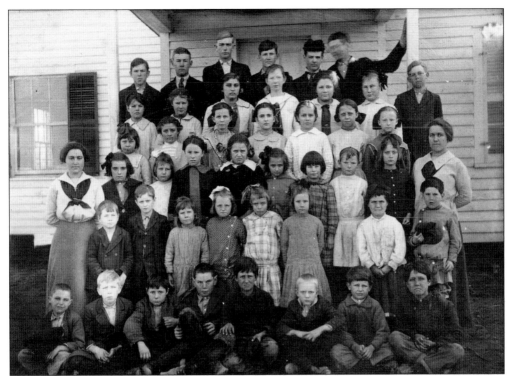

Even after the graded school system was established, some of the community's smaller schools continued to combine children of various ages into a one-room or small-building environment. This is a portrait of the Furr School class of 1913–1914. The teachers are Mary Pharr (left) and Amanda Krimminger (right). Furr was located where Northwest Cabarrus High School is today.

During the 1920s, many working-class Concord families could not afford shoes for their children, hence the barefoot students in this 1921 photograph. This was a class from the Central Graded School, built in 1901 on the west side of Spring Street and Grove Avenue, where Coltrane-Webb Elementary stands today. (Courtesy of St. James Lutheran Church.)

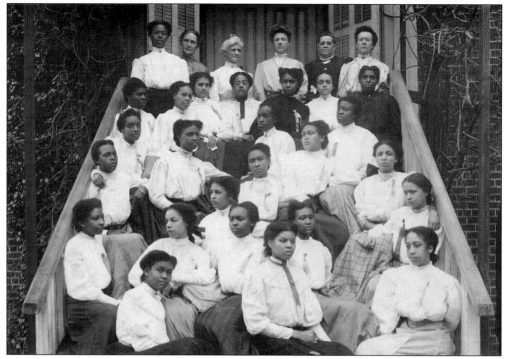

Scotia Seminary, now known as Barber-Scotia College, was founded in 1867 by Presbyterian minister Rev. Luke Dorland. The institution was established to instruct recently emancipated African American women in education and domestic skills. Classes included algebra, grammar, geography, physiology, botany, domestic economy, plain sewing, cooking, and teaching theory and practices. During its early years, most of Scotia Seminary's teaching staff was white, as were its first five presidents. The photograph above depicts a Scotia class of 1907. The photograph below was taken in 1916, the year the school changed its name to Scotia Women's College. The gentleman standing on the right in that picture is A. W. Verner, the college's third president, who presided over the school from 1908 to 1922. (Both, courtesy of Barber-Scotia College.)

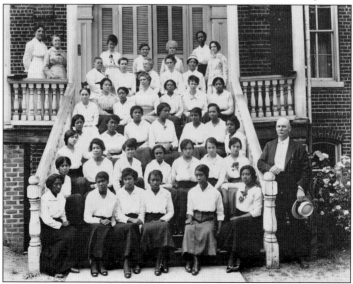

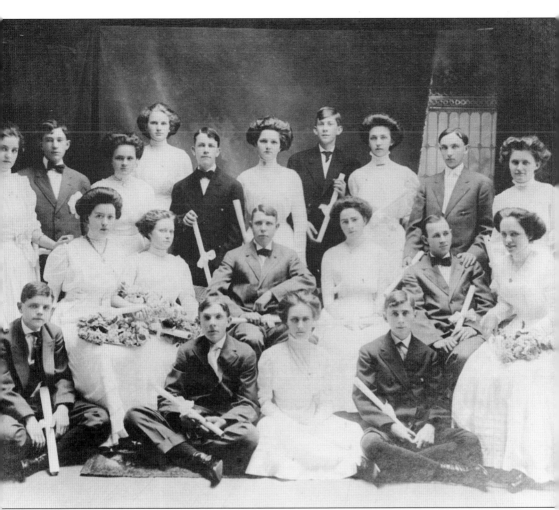

The Concord High School class of 1909 was, during the infancy of the city's graded school system, the first to complete 10 grades, as well as the first to graduate from the Central Graded School. A. S. Webb, a venerated Concord teacher who later became superintendent, was a first-year teacher when he instructed this class, and L. D. Lentz was the school principal. From left to right are (first row) Warren Moody, Harold Dayvault, Fannie Morrison, and Ephraim Tucker; (second row) Sue Caldwell, Frances Craven, Eugene Fink, Grace Watkins, John Boger, and Rita "Lot" Culp; (third row) ? Covington, Ernest Porter, Laura Grant, Myrtle ?, Joe "Fred" Correll, Eleanor Norman, Frank Cline, Audrey "Hallie" Earnhardt, Lester D. Coltrane Jr., and Dollie Blackwelder. (Courtesy of Iris Kelley.)

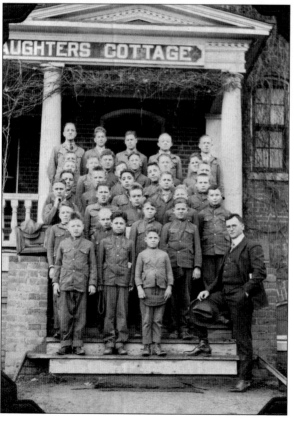

Stonewall Jackson Training School, founded in 1909 as the Stonewall Jackson Manual Training and Industrial School, was North Carolina's first correctional institution for delinquent boys. Fundamental in its creation was James P. Cook, editor of Concord's *Daily Standard* newspaper, who, while covering a court trial, was dismayed to witness a lad being sentenced to an adult chain gang for stealing a mere $1.30. Cook garnered community backing to create a facility for boys that would offer vocational training. The 1920s photograph above depicts, from left to right, some of the school's 15 cottages, the Administration Building (with columns), and the gazebo. In the picture at left, also from the 1920s, uniformed boys and an instructor pose on the steps of cottage no. 1, which bears the name of the King's Daughters, a women's group that assisted Cook in starting the school.

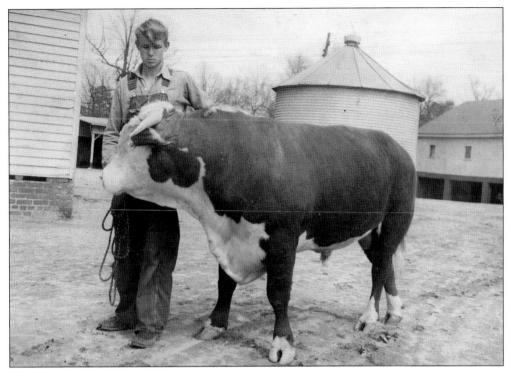

Acres of farmland were added to Jackson Training School in the 1920s, offering students agricultural training through its dairy farm, livestock, and fruit and pecan orchards. This afforded the complex autonomy and sustainability, and local merchants opened businesses in the vicinity to take advantage of the fresh, delicious meals they could eat on campus.

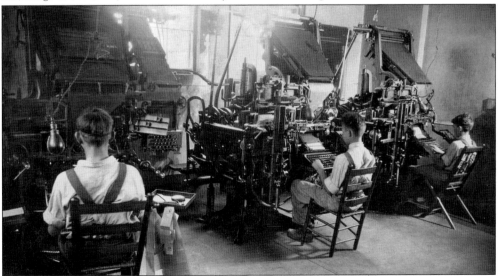

Jackson Training School's print shop was one of the many vocational opportunities provided for its students. From the 1920s through the 1940s, the print shop was run by Leon Godown. The *Uplift*, the school's weekly newsletter, was produced here. As of this writing, the school is operating as the Stonewall Jackson Youth Development Center, housed in newer facilities behind the abandoned original cottages.

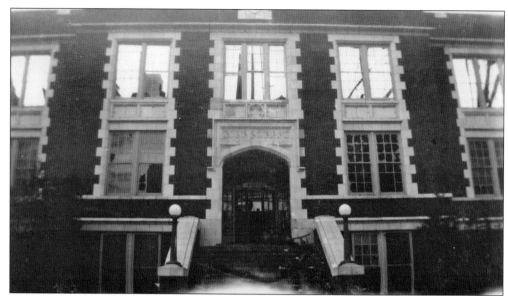

Built in 1924 after the passage of a $225,000 bond, the beloved Concord High School on Marsh Avenue has rarely been seen in the condition depicted here. A 1937 fire severely damaged the building, as can be seen by looking through the vacant second-story windows. The auditorium and gymnasium were completely rebuilt, and a new wing was added. (Photograph by Zack Roberts; courtesy of George M. Patterson.)

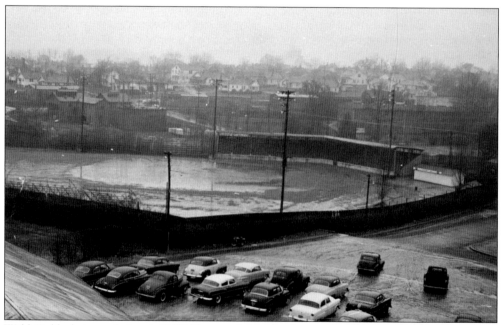

Webb Field, christened after A. S. Webb, one of the school system's earliest teachers and principals, was built behind the old Concord High School to host games for the school's various athletic teams; semipro baseball games were also held here. From Webb's name came the school's mascot moniker, the "Concord Spiders." If there was a game scheduled on the dreary 1940s day this photograph was taken, it was no doubt postponed.

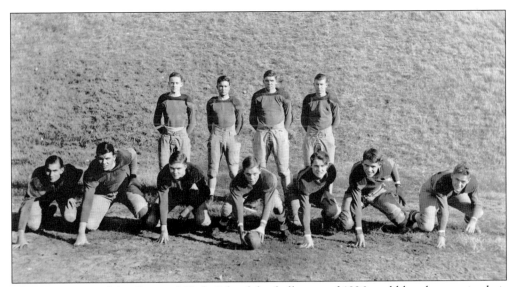

The young men of the Concord High School football team of 1936 could barely contain their energy when posing for their portrait, taken by photographer Zack Roberts. Members of the squad were (listed alphabetically) Bill Barber, Ed Barrier, Jim Beaver, Gene "Blackie" Blackwelder, Carl Connell, Jim "Corkey" Faulkenberry, Boney Greene, Ernie Tate, and Fred Walters. One of the players' names was not available. (Courtesy of George M. Patterson.)

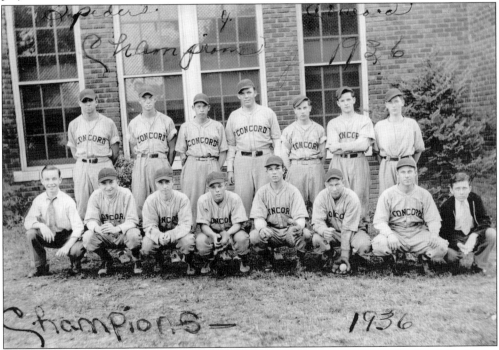

The 1936 Concord Spiders baseball team proudly slugged their way to win the South Piedmont Conference Championship. Members of the team were (listed alphabetically) Jimmy Alexander (manager), "Shorty" Allred, Jim Beaver, Bedford Biles, "Lefty" Bratton, Jim Fauklenberry, Marshall Goldstein, Boney Greene, L. C. Harmon Jr., Harry Hollingsworth, Johnny Jones, Ray Lippard, Bill Morrison, Earl Walters, Fred Walters, and Earl Williams. (Courtesy of George M. Patterson.)

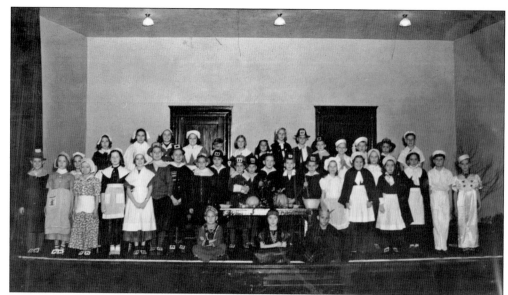

Clara Harris School was originally the Corban Street School, an elementary located at the original site of the St. James Lutheran Church, next to today's Cabarrus County Jail. It opened in 1929 under the watch of principal Mary W. King and was renamed in 1935 in honor of its beloved art teacher. This 1939 Thanksgiving play was certainly the delight of many teachers and parents.

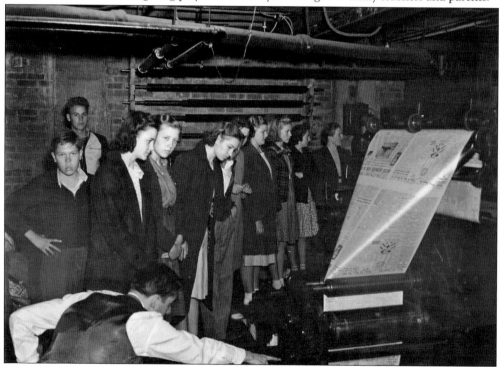

High school students from Hartsell School, in southwest Concord, learned firsthand about newspaper publishing on November 13, 1939, when touring the offices of the *Concord Tribune*. Hartsell discontinued its high school classes in 1966 but remains active as an elementary school. (Photograph by Zack Roberts; courtesy of the Concord Public Library.)

Concord's African American students, like white students, were educated in church schools in the 1800s—most notably, in schools operating through Grace Lutheran Church. When the city of Concord initiated public (graded) schools in 1891, the Concord Colored School opened. Appointed as its teacher and head administrator was Rev. Frank T. Logan, a former slave from Greensboro. (Courtesy of the Concord Public Library.)

The Concord Colored School took the name of its administrator, Rev. Frank T. Logan, and became Logan School in 1924 when an expanded facility was built in southwest Concord. Students and faculty saluted their American heritage at this patriotic event held at the school in the mid-1940s. (Courtesy of the Concord Public Library.)

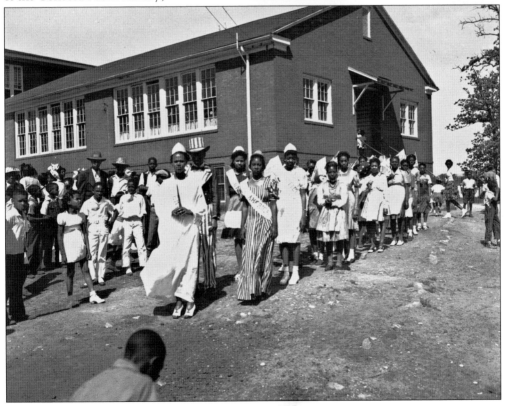

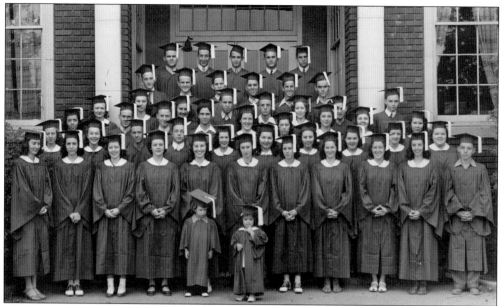

Winecoff Elementary School today educates children in the northwest corridor of Concord, but in the mid-20th century, it was also one of the city's high schools. The photograph above features the senior class of 1942. In the photograph below is Mary Propst's 1955–1956 first-grade class at Clara Harris School. From left to right are (first row) Neal McQueen, Larry Bonds, Robert McGee, Paulette Williams, Charles Sutton, and Rebecca Sutton; (second row) Janice Moore, Judy Snowden, Susan Ruehler, Vicki Carnes, Tommy Fink, Eddie Barnhardt, Thurman Stone, Donna Stirewalt, and Sondra Burleyson; (third row) Martha Campbell, Dianne Plyler, Becky Hart, Pixie Gordon, Steve Bishop, Jan Faggart, Hester Dorton, Beverly Jo Patterson, and Peter Graves; (fourth row) Lane Wise, Skipper Alexander, Terry Ledford, Danny Sartis, Judy Barnhardt, Homer Freeman, Billy Coley, Dale Jones, Harold von Cannon, and Kess Whitener. (Above, courtesy of Don Hancock.)

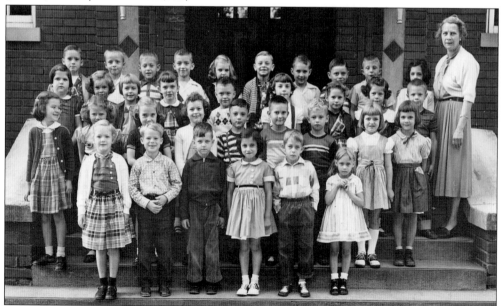

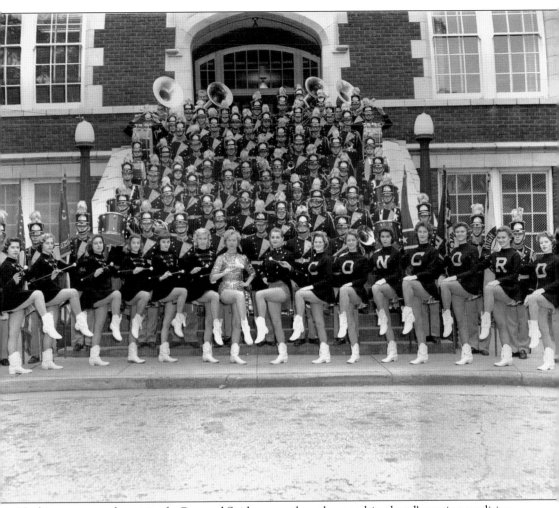

Nothing peps ups the spirit of a Concord Spider more than the marching band's rousing rendition of the school fight song, "Our Director." The Marching Spiders of 1960, under the field direction of drum major Gene Furr, stand in formation on the front steps of Concord High School. The majorettes are, from left to right, Shelley Brinkley, Ellen Midkiff, Pru Edwards, Kay Smith, Temperance Lentz, Patsy Faggart, Linda Edwards, and Emily Patterson; and the letter girls are, from left to right, Sally Purnell, Linita Craven, Mary Knight D'Oyley, Linda Swaringen, Carol Carden, Susan Dennis, and Ruby Jane Ward. A full reckoning of the band's roster is on display at the Concord Museum. (Courtesy of Jim Kee.)

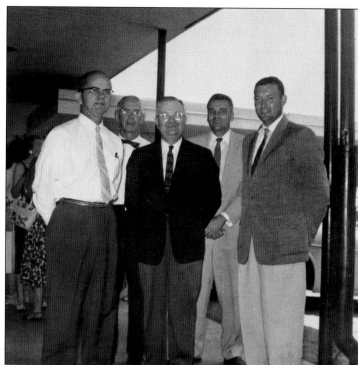

Concord school administrator R. Brown McAllister (center) stepped down as superintendent in 1957 after holding the position since 1943, and this party was held in his honor at Beverly Hills Elementary. From left to right are Ralph Glenn, John McInnis, McAllister, Bill Irvin, and Joe Fries. Each gentleman ascended to great heights within the school system.

Several members of the 1958–1959 Concord High School Student Council went on to become prominent businessmen and community leaders. Members of the council are (seniors) Knox Hillman and Ann Barnhardt; (juniors) Ronnie Williams and Sharon Howell; (sophomores) John Morrison and Betsy McLean; (freshmen) A. R. Hudson and Ann Wallace; and (eighth graders) Bill Howard and Jackie Crouch. (Courtesy of Concord High School.)

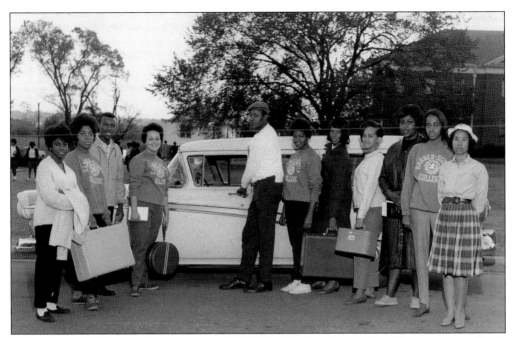

Barber-Scotia College students convene with fellow Presbyterian students for a retreat to Camp Grier in this 1961 photograph. The Barber-Scotia students (in sweatshirts) are, from left to right, Vera Manigo, Maria Hampton, Valeria McAdams, and Emogene Spence. (Courtesy of Barber-Scotia College.)

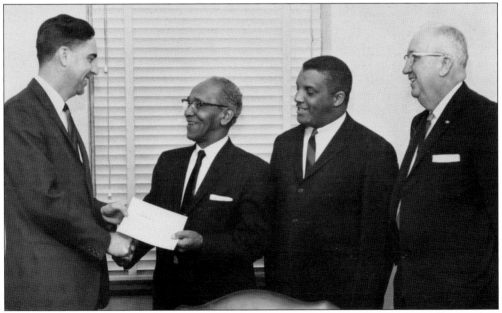

Leland Stanford Cozart (second from left), the sixth president of Barber-Scotia College and its first African American president, gratefully accepts a $250 grant from P. V. Guyton (left) of Gulf Oil Company on April 19, 1964, in this photograph by James Babb. Originally Scotia Seminary, the school adopted the name Barber-Scotia College in 1932 after merging with Barber Memorial College of Anniston, Alabama.

"Ye shall live to regret this day, sister . . . if you don't hold still while I put on your makeup . . . !" reads an anonymously written inscription in the scrapbook of the 1964 Concord High School Dramatics Club. The woman applying makeup to this unidentified student is Blanche Stewart, who taught history and other subjects at the school for several generations. (Courtesy of Concord High School.)

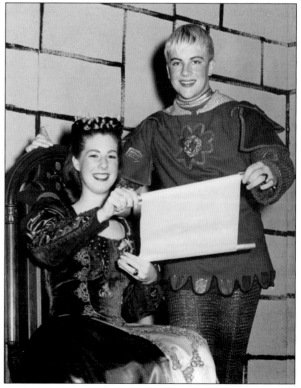

Concord High School's Dramatics Club has a long reputation for top-notch performances. Queen Guenevere (Candy Kimbrell) and Sir Lancelot (Phil Wilson), both wearing CHS high school rings, strike a publicity pose for the 1964 production of *A Connecticut Yankee in King Arthur's Court*. Wilson went on to become one of Concord's favorite middle school teachers. (Courtesy of Concord High School.)

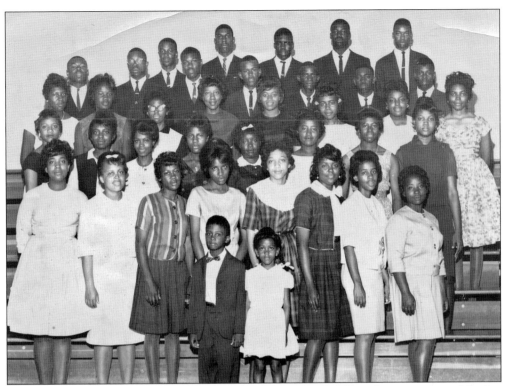

Changes were in the air when the Logan High School class of 1963, with mascots, posed for this class portrait. A gradual integration of black and white schools would soon begin in Concord. Members of this class include Vivian Davis, Priscella Jordan, Earlene Oates, Kenneth Reid, and Carolyn Robinson.

In this photograph, R. Brown McAllister Elementary School PTA members display motherly affection for their children's school by producing heart-shaped Valentine posters for a February 1964 fund-raiser. From left to right are Mrs. William Patten, Mrs. Dan Harrell, and Mrs. Harold Hornaday.

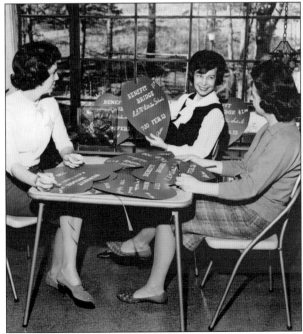

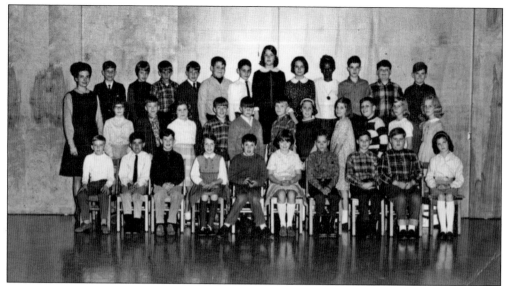

During the 1966–1967 school year, school integration commenced on a voluntary basis, with Logan students being allowed to choose which of the city's previously all-white schools they wished to attend. This photograph from Frances Ann Baucom's fourth-grade class at R. Brown McAllister Elementary shows the beginning of this cultural merger. Desegregation became mandatory with the 1969–1970 school year. (Courtesy of the author.)

The annual high school football clash between Concord and A. L. Brown (Kannapolis) dates back to 1931, making it North Carolina's second-oldest continuous football rivalry. For years it was preceded by Concord's mock funeral for the "Little Wonder," a dummy dressed in an A. L. Brown uniform. "Grieving" Concord students pretending to be from the Wonder's "family" would boo-hoo their way through this riotous event. (Courtesy of Rosemary Goodman.)

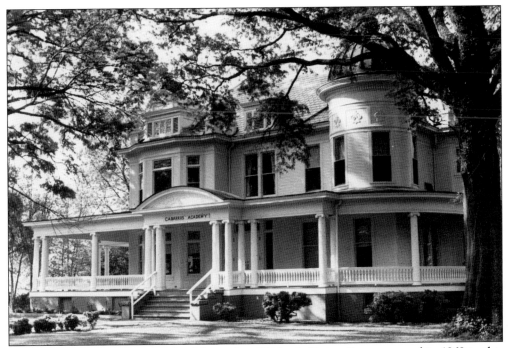

Cabarrus Academy, a private school located at 65 North Union Street, opened in 1969 in this historic Queen Anne/Colonial Revival home built in 1900 by James W. Cannon, the founder of Cannon Mills. In 1994, Cabarrus Academy relocated to its current 65-acre campus on Poplar Tent Road. The J. W. Cannon home is once again a private residence.

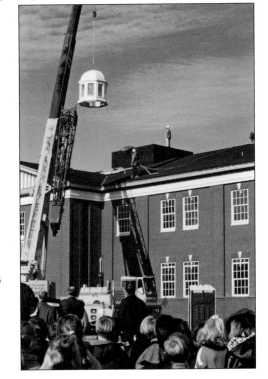

The completion of Cabarrus Academy's new location in 1994 drew an exuberant response from students and faculty. The institution was renamed Cannon School in 1998, and it is now regarded as one of the Charlotte region's best college-preparatory schools, attracting students from Charlotte, Lake Norman, Mooresville, Cornelius, and Salisbury, as well as Concord. (Courtesy of Cannon School.)

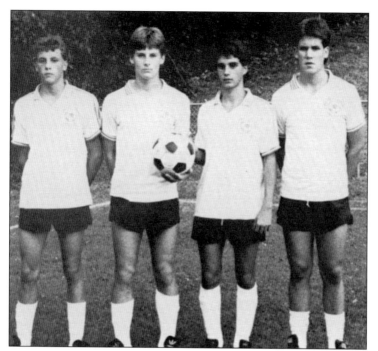

Northwest Cabarrus High School was founded in 1966 when Winecoff and Odell schools amalgamated their high school classes. Bryan "Skeet" Ulrich, a 1988 graduate, departed Concord for Hollywood and has scored an impressive list of screen credits, including the movie *Scream* and the television series *Jericho*. Soccer cocaptain Ulrich is at left in this yearbook photograph from his senior year. (Courtesy of Northwest Cabarrus High School.)

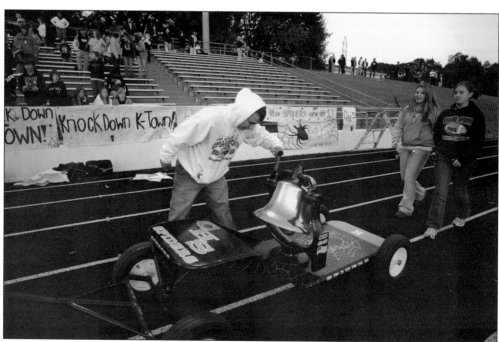

Each year's victor of the long-running Concord/Kannapolis football clash nabs this highly coveted railroad bell and paints it in their school's colors; the game today is commonly known as the "Battle for the Bell." This 2006 photograph by Bridgett Baker was taken at Concord High School's current location on Burrage Road, which opened in 1967. (Courtesy of the *Independent Tribune*.)

Five

CONCORD BUSINESSES

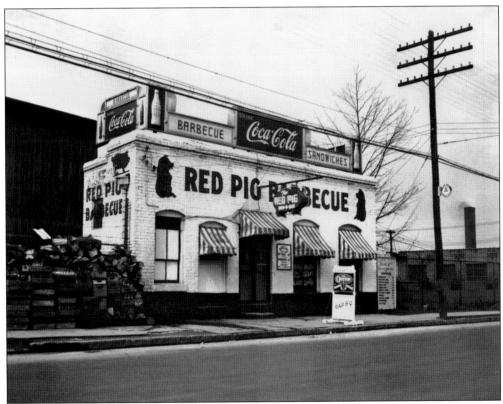

If the sweaty labor in adjacent Locke Mill was not enough to work up an appetite, the intoxicating aroma of hickory-wood, pit-cooked barbecue would certainly lure workers here. The Red Pig, long a tradition in the Concord area, operated at this unassuming location on Church Street just north of Buffalo Avenue in what was originally a mill superintendent's office.

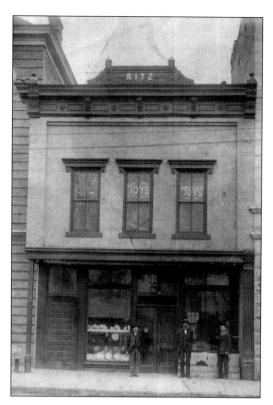

Harry Ritz, at left in this 1917 photograph, was a transplanted Yankee who grew up in Washington, D.C., during the Civil War, but he earned the admiration of locals thanks to his work ethic, honesty, and knack for minding his own business. Ritz Variety Store opened in 1903 on South Union Street facing Means Avenue, having moved down the street from a small store that was nicknamed "the Hole in the Wall."

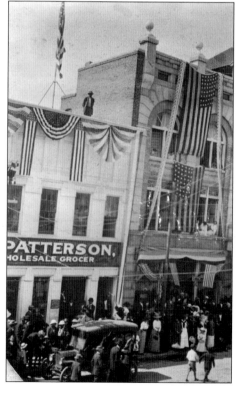

G. W. Patterson's wholesale grocery store at 36–38 South Union Street was a hot spot for men as Concord's lone distributor of Havana Ribbon 5¢ cigars. Food, grain, feed, and sundries were also available there. Patterson's and the Pythian Building next door offered prime perspectives for parade viewers on this festive day in the late 1910s. (Courtesy of Alex Patterson.)

Downtown Concord's "back lots," located between South Union and Church Streets, were often used for deliveries to the businesses that fronted Union Street. Roy Burrage gallops fresh milk from the Co-Operative Dairy to a customer in the photograph at right, taken in the late 1910s. Co-Operative Dairy was the county's first central source where area farmers could bring their milk for bottling. The switchboard operators of the Concord Telephone Company connect for this popular 1921 photograph shot behind Gibson's Drug Store, which was located on Union and East Depot Streets at the square. From left to right are Glenna Culp, Maude Dry, Marian Myers, Mary Cline, Addie Ridenhour, Blanche Swink, Mary Hill, Etta Belle Smith, Velma Lyles, Maybelle White, Lillian Wiley, and Maxine Crowell. (Right, courtesy of Robert E. Burrage.)

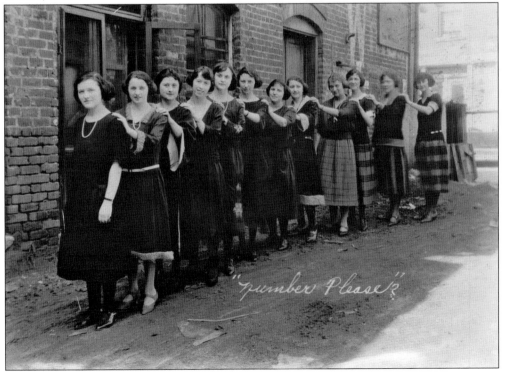

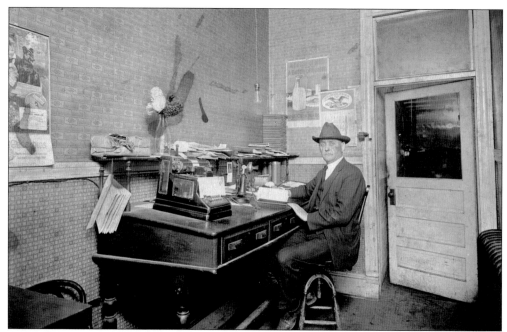

Concord dairy mogul Robert L. Burrage Sr. got his start in the 1900s selling milk and eggs to neighbors from his farm. He was bottling under the name Burrage Dairy in 1908, and in 1917, he partnered with other small farmers and became general manager of the Co-Operative Dairy. This 1923 photograph shows Burrage in the Co-Operative Dairy office at 95 South Union Street. (Courtesy of Robert E. Burrage.)

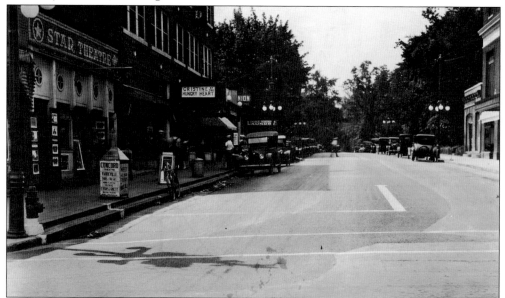

Two of downtown Concord's movie theaters are visible in this 1924 photograph shot at the square facing northwest. The Star Theatre was later renamed the State Theatre. In its location at this writing is the Bead Lady shop. The Concord Theatre, then showing *Christine of the Hungry Heart*, also featured vaudeville and other live performances. It was later known as the Paramount, then the Center, and finally the Cinema.

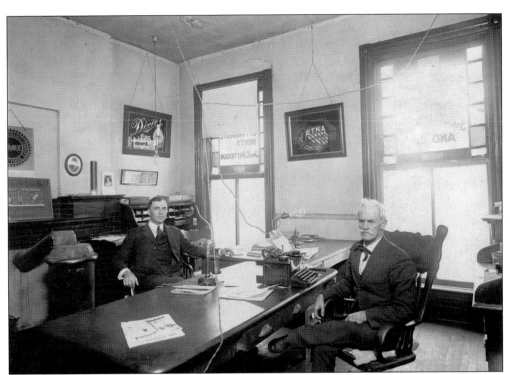

John K. Patterson (above, right), at one time the county's register of deeds, was vastly respected within Concord for his insurance and real estate businesses. Patterson sold land options for 600 acres north of Concord to James W. Cannon, and there Cannon developed his mill village of Kannapolis. Patterson, with his son S. Kay Patterson, is seated in his second-floor office in the Phifer Building on South Union Street. The junior Patterson's hobby was kite-making, and folks back in the 1930s would often crane their heads up to spy kites twice as tall as a man being flown from the fields of Jackson Training School. S. Kay cleverly used the 15-foot-by-12-foot kite seen in the photograph at right, taken around 1932, to advertise the family business. His son Alex Patterson is on his shoulders. (Courtesy of Alex Patterson.)

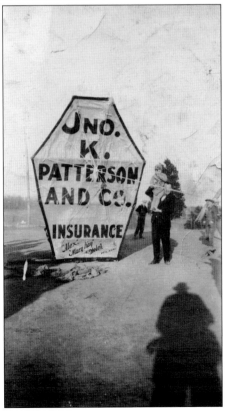

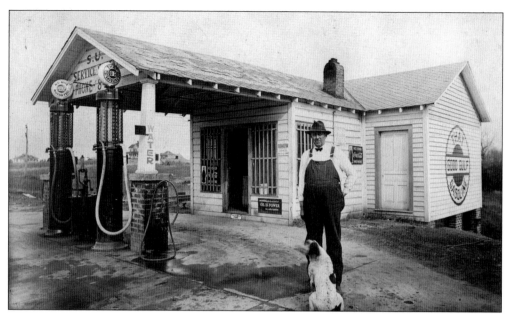

Robert Franklin Weddington operated this Gulf service station in the 1920s on South Union Street, just south of what is McAllister Avenue today. This sparsely developed neighborhood now hosts the heavily populated community surrounding R. Brown McAllister Elementary School. In later decades, on the site of Weddington's Gulf was a small brick gas station/convenience mart called, at different times, Teeter's and Pettus's. (Courtesy of James E. Weddington.)

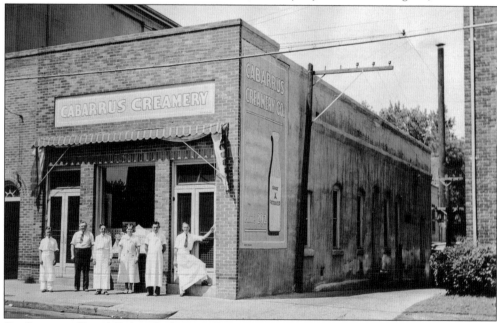

Co-Operative Dairy's Robert L. Burrage Sr. was approached by investors in 1924 about a merger with a butter plant called Cabarrus Creamery Company, Inc. This 1931 location of the creamery was on South Union Street, north of where the *Concord Tribune* would later be located. From left to right are Robert L. Burrage Jr., Charles E. Burrage, Bill Scott, Daisy (Barnhardt) Burrage, Buford Misenheimer, and Franklin Scott. (Courtesy of Robert E. Burrage.)

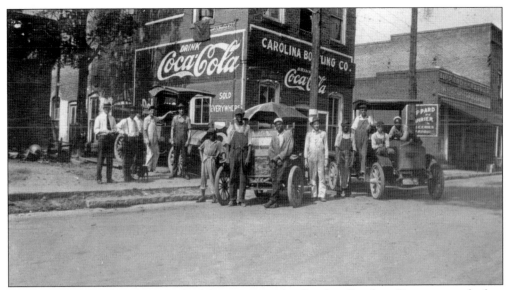

Motor trucks picked up the pace for deliverymen at the Carolina Bottling Company in the late 1920s and early 1930s. This Coca-Cola distributor was located at the corner of South Church Street and East Depot Street until it moved in 1935 to an expanded plant on North Church Street. Owner J. T. Honeycutt is visible at the far left. (Courtesy of Sun-drop.)

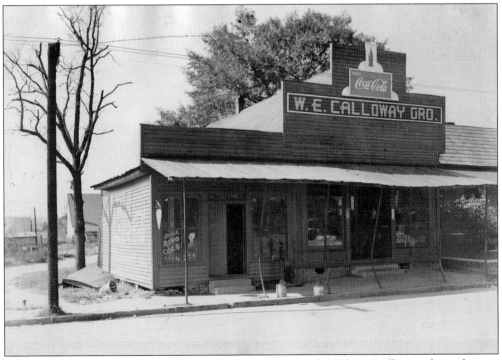

W. E. Calloway operated this grocery at 81 Harris Street in the Gibson Mill area, shown here in a late-1930s photograph by Zack Roberts. In the store's floor was a trap door containing a coop into which live chickens were dropped for slaughtering. (Courtesy of George M. Patterson.)

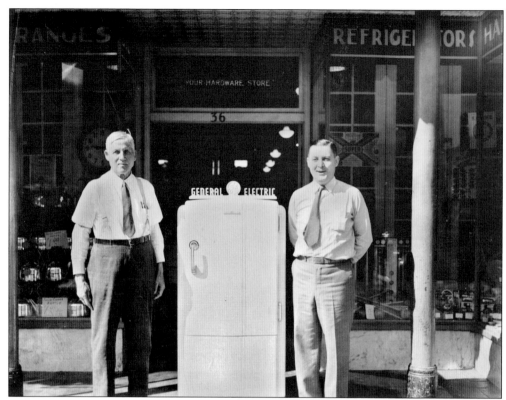

Charles F. Ritchie (left) sold hardware and agricultural tools from 36 South Union Street, in the Pythian Building, beginning in the early 1900s. By the time this photograph was taken in 1938, Charles, shown with son Bill Ritchie, had expanded his line to include electric appliances, sporting goods, and glassware. The photograph below is the interior of the store, showing some of Ritchie's wares, including radios, washing machines, and ranges. Another division of his company was Ritchie Auto Parts at 35 South Spring Street, operated by Patt Ritchie. (Both, photographs by Zack Roberts; courtesy of George M. Patterson.)

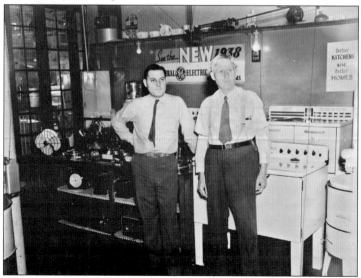

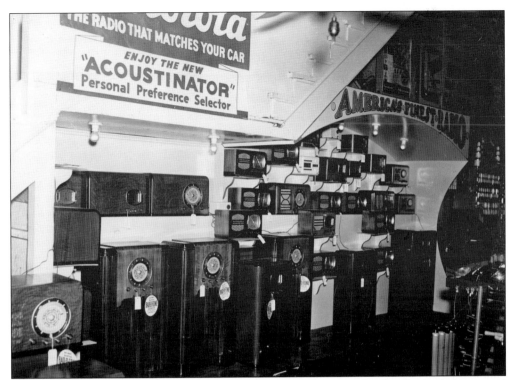

Hunter Radio, later Hunter Radio and TV, offered a full range of radios for both home and automobile in the late 1930s. Its location was the corner of Barbrick Avenue and South Spring Street, where CESI Land Development Services is located at this writing. (Photograph by Zack Roberts; courtesy of George M. Patterson.)

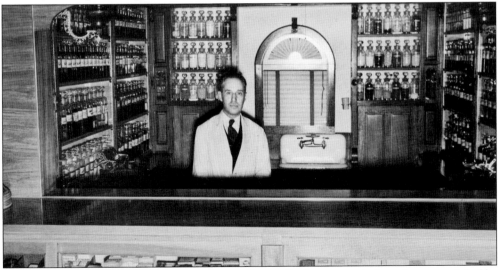

In the days before box stores and mega-chains, Concord's pharmaceutical needs were satisfied by several regional drugstores, most of which also featured snack counters. Joining local favorites such as Gibson's, Pike's, Airheart's, and Pearl Drug was Porter Drug Company, located just south of the town square on South Union Street. This April 1940 photograph, culled from a Jackson Training School scrapbook, shows the well-stocked prescription counter.

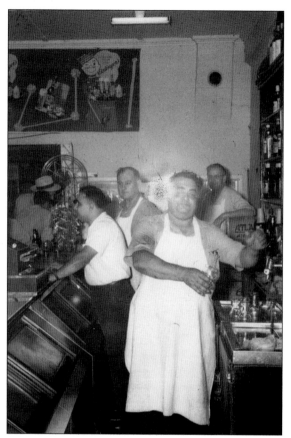

The unfortunate flash on this late-1930s photograph cannot dim the magic that was Williams Candy Kitchen, a kaleidoscope of conversations, peanut smells, and tasty taffy. In 1929, J. B. Williams (front) and his wife, Rosa "Mom" Williams, launched their enterprise next door to North Union Street's Pastime Theatre and sold popcorn and candy to moviegoers before the theater opened its own concession stand. The beer sales shown here were short-lived, but the Candy Kitchen stocked a little bit of everything, from ice cream to magazines. At one time or another, Williams's children—Charlie, Mary, Taffy, and Tommy—worked at the Candy Kitchen, the latter starting when he was only seven. Williams moved the shop to Barbrick Avenue in 1945, within the cluster of businesses shown in the photograph below, and Tommy Williams and his wife, Lorraine, eventually took over. Williams Candy Kitchen closed in 1988 when the entire block was razed to build municipal parking. (Left, courtesy of Jimmy Auten.)

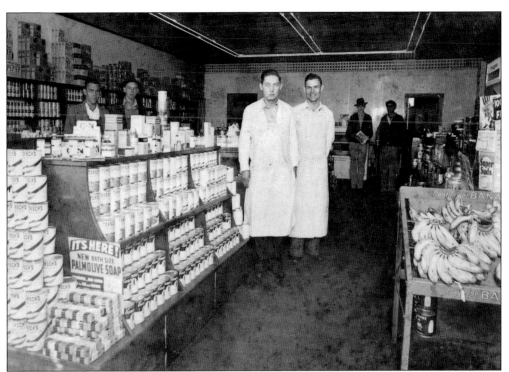

Catering to the Gibson Mill community, H. G. Blackwelder opened a grocery store on McGill Avenue at the mouth of Kerr Street in the 1930s. Woodie's Barber Shop was located next door. Blackwelder's Grocery was remodeled and expanded in 1957 and remained in business until the 1970s. From left to right, the men in the foreground are Blackwelder and his butcher, J. Brite Thompson.

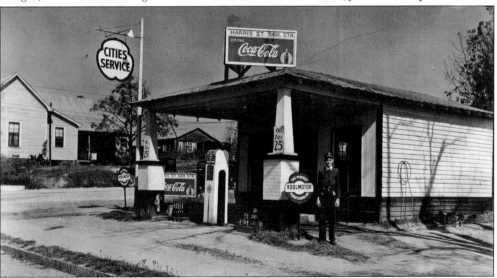

Just around the corner from Blackwelder's Grocery was the Harris Street Service Station, at Harris and Brookwood Avenue, seen here in 1938. While this independently owned business lacked the sharply tailored uniforms worn by many of the major gas companies, that did not dissuade them from trying to put their best sartorial foot forward. (Photograph by Zack Roberts; courtesy of George M. Patterson.)

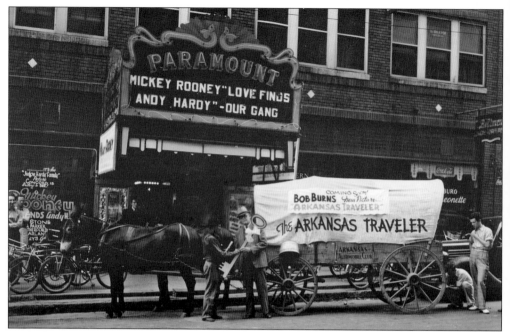

Once the Concord Theatre became the Paramount, its facelift included a glitzy marquee and imaginative storefront displays. In this 1938 photograph, Mayor W. A. Wilkinson takes advantage of the promotion for the upcoming movie *The Arkansas Traveler* to present a key to the city to one of the production's personnel. (Photograph by Zack Roberts; courtesy of George M. Patterson.)

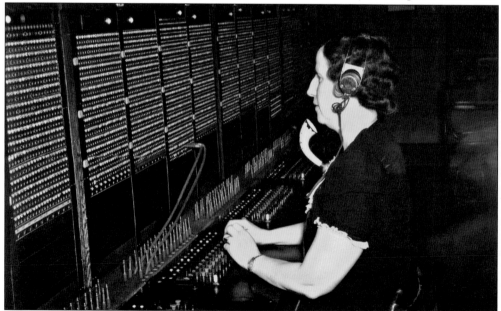

Working as a switchboard operator for the Concord Telephone Company required attention to detail and a cheery disposition. Originally, CTC's callers relied upon an operator like this one to connect them with their parties. Once the company switched over to a dial system in April 1940, when this photograph was taken, over 5,000 customers were able to telephone their parties without operator assistance. (Courtesy of the Concord Public Library.)

A legion of local merchants grabbed advertising spots on this 1930s official scorecard for the Concord Weavers semipro baseball team. Additional businesses listed inside or on the back of this 10-by-7-inch flyer include Deluxe Barber Shop, Concord Motor Company, Sterchi's, Kestler Brothers Printers, Bob's Laundry, and Elizabeth's Smoke Shop. (Courtesy of Robert E. Burrage.)

On Kerr Street behind Webb Field was the Concord Ice Delivery Company, best known to folks in town as the "Ice House." Once electric refrigerators melted ice sales, the plant used this irresistible summer 1940 photograph featuring Snooky Ritchie, daughter of Bill and Lily Ida Ritchie, to drum up business. (Courtesy of the Concord Public Library.)

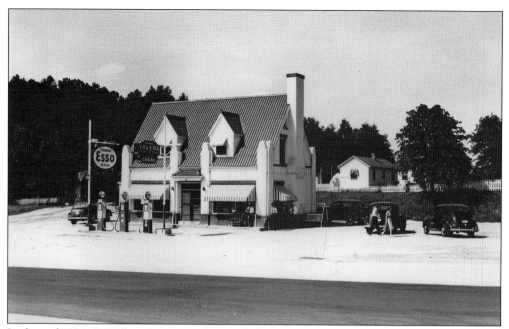

In the mid-1930s, J. William Propst Jr., along with brothers Clyde, Earl, Carl, Ben, and Phil, realized the potential of the emerging car culture and created businesses to support it, including the hauling company Propst Transport and gasoline distributor Propst Brothers. Another venture, adjacent to an Esso Station on Highway 29 North, was the Pine Tavern, a precursor to the roadside motor court. Tourist cabins, each named after a state, stood behind the tavern. If travelers did not pull in on their own volition, one of its carhops might sprint alongside their vehicle, hop onto their running board, and try to coerce them into stopping. This business started in 1937 and remained open until the early 1960s. In the interior photograph, Woodrow Whitesell is the man at the far right; the others are unidentified. (Both, courtesy of Kenny Propst.)

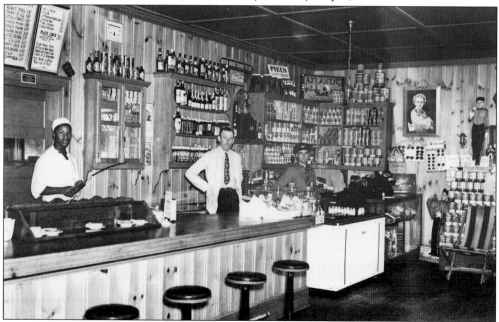

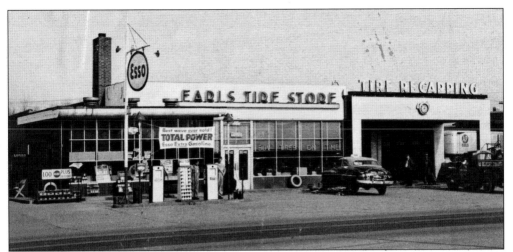

After William Propst Jr. acquired 140 acres on North Church Street in 1937, a contest was held to select a name for the development. The winning entry of "Wil-Mar" combined the first part of the names of Propst and his wife, Margaret. Wil-Mar Park's first new business was Earl's Tire Store, which opened on North Church Street in March 1940. Operated by (and named for) William's younger brother, Earl Propst, Earl's Tire Store promptly added recapping services to combat the tire and rubber rationing that soon occurred due to World War II. A two-bay recapping garage was constructed beside the sales room, as seen in the above picture. Earl's wife, Frances, was the business's bookkeeper. The photograph below, from 1940, shows the Propsts in the office of Earl's Tire Store. (Both, courtesy of Kenny Propst.)

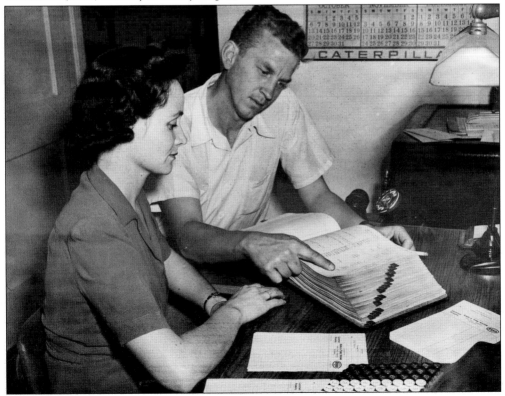

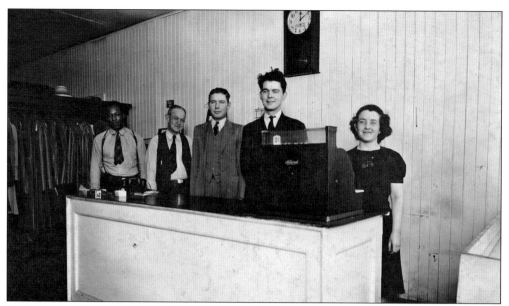

M. L. "Luke" Young and his wife, Anna, opened Young Cleaners on North Church Street in February 1941. Young developed a reputation for dealing with difficult stains, which encouraged other cleaners to seek his advice. Today his son Martin operates the business. From left to right in this 1941 photograph are Jack Cherry, Russell Devoroe, Clay Baucom, M. L. Young, and Anna Young. (Courtesy of Martin Young.)

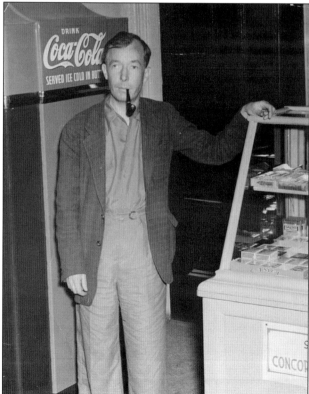

Fulfilling its mission of helping those with vision impairments, the Concord Lions Club sponsored this tobacco stand in the Cabarrus County Courthouse, managed by Pluto Wood, who was legally blind. This photograph by Zack Roberts was taken in April 1941. (Courtesy of Don Hancock.)

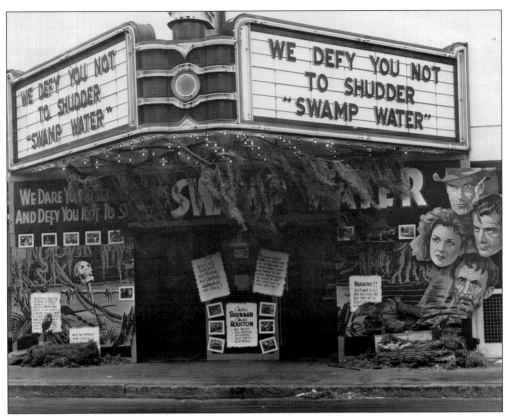

When the Cabarrus Theatre opened on North Union Street next to Central Methodist Church in June 1939, it was the city's first air-conditioned business. Its original manager, D. B. Austell, was a flamboyant showman who frequently decorated the front and lobby of the building with elaborate displays, such as this one for the 1941 thriller *Swamp Water*. (Courtesy of Jimmy Auten.)

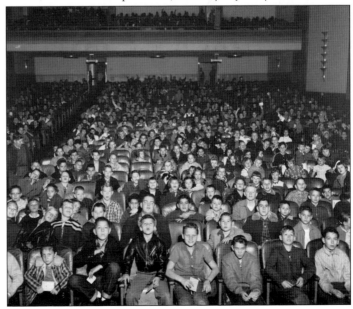

The interior of the Cabarrus Theatre featured recessed stadium seating and a balcony. The latter was called the "Colored Balcony" during segregation, and African American patrons were relegated to seats there. Malcolm "Purnie" Purnell managed the Cabarrus from the 1950s through its closure in the 1970s and often sponsored special presentations for kids, such as the one taking place in this December 1959 photograph by Lawson Bonds.

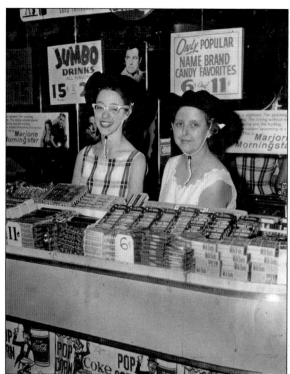

"Only popular name brand candy favorites" were sold at the Cabarrus Theatre's concession stand, called the Candibar, a visual and taste treat that was as memorable as many of the films shown at the theater. From left to right are Beverly Newton and Rachel Wilhelm in a 1958 photograph.

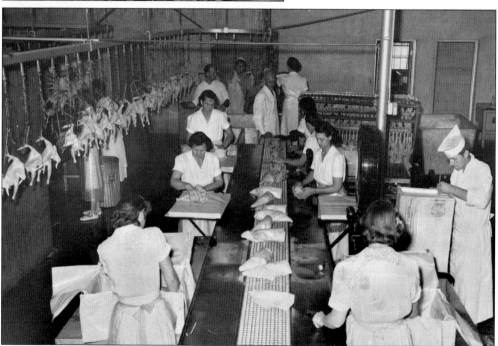

Perdue Farms, Inc.'s Concord cook plant, located at the end of Harris Street near U.S. 29A (Concord Parkway), remains in operation today after decades at this location. Arthur W. Perdue started the national poultry chain in 1917. This 1951 photograph by Jimmy Babb shows the chicken-wrapping assembly line at the Concord facility. (Courtesy of Kenny Propst.)

W. W. Kale and Algie Lawing founded Kale-Lawing Company Office Outfitters in Charlotte in 1925 and expanded into downtown Concord in 1948. Their original Concord location was on South Union Street in the old Citizens Bank and Trust Building. This photograph was taken in 1955, just after Kale-Lawing had moved up the street to a larger location. (Courtesy of Christopher Lawing.)

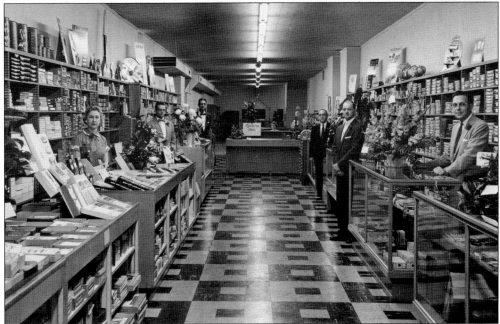

Kale-Lawing's courteous and attentive staff was always poised to help the shopper find products within the store's deep stock of office supplies. This is a photograph from the 1955 grand opening of its second location, at 21 North Union Street. Bill Lawing is the second figure from the left; W. W. Kale is in a dark suit at center right. (Courtesy of Christopher Lawing.)

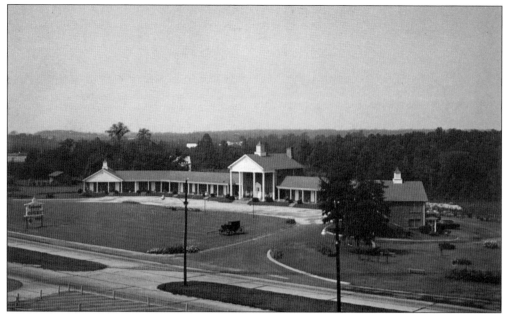

Colonial Motor Court, seen here in a picture postcard, was strategically positioned in north Concord at the junction of two major highways, U.S. 29A and U.S. 601. During simpler times, the motel's advertised private tile baths and radios attracted motorists for a relaxing night's stay. Its location was across from what today is Carolinas Medical Center NorthEast. (Courtesy of Kenny Propst.)

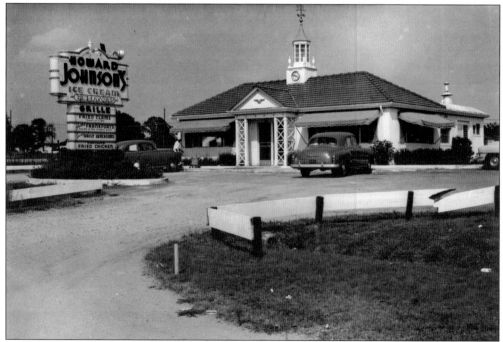

The first Howard Johnson's restaurant between Virginia and Florida was in Concord, next to the Colonial Motor Court. Bob Williams was its owner. It opened in the late 1940s and catered to both motorists visiting town on business and to motel guests. (Courtesy of Kenny Propst.)

The Food Centre, co-owned by O. A. Swaringen and James Jackson, was a Concord chain of three grocery stores from the 1950s through the 1970s. Food Centre No. 1, catering to downtown shoppers, was located on South Spring Street at the corner of Corban Avenue. Stock manager Ray H. Eury is seen in this 1955 photograph. (Courtesy of Aggie Eury.)

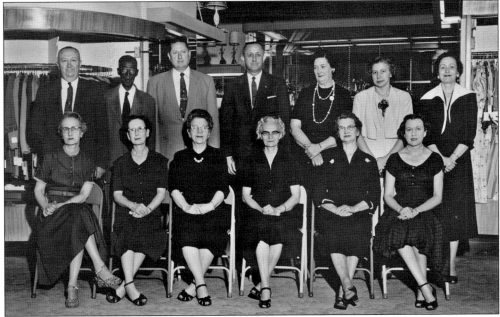

For decades, Belk Department Store anchored downtown Concord's shopping district from its four-story 11 South Union Street location. Belk's sales staff shown in this 1955 picture are, from left to right, (first row) Cora Fisher, Inez Troutman, unidentified, ? Kiser, unidentified, and Hazel Click; (second row) Charlie Sides, Joe Moore, Clarence Dellenger, manager Ray Cline, Bell Morrison, Helen Hancock, and Estel White. (Photograph by Lawson Bonds; courtesy of Phyllis Blackwelder.)

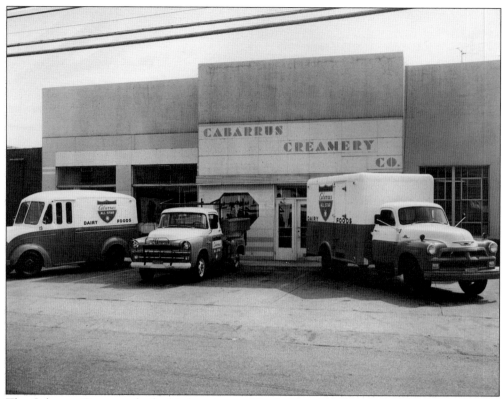

The Cabarrus Creamery built this location on North Church Street in 1940, next door to the Coca-Cola plant. The creamery joined the All Star Dairy Association in 1954, allowing the independent business to buy cartons and supplies at competitive prices. The building's exterior was bricked over in the early 1980s, and the family-owned business was sold in 1999. (Photograph by Lawson Bonds; courtesy of Robert E. Burrage.)

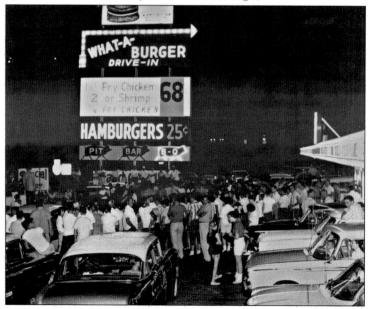

This *c.* 1957 rock-and-roll concert and sock hop flooded the What-A-Burger Drive-In on Highway 29A (Concord Parkway) with rollicking teenagers and curious families. Ed Bost started What-A-Burger in Concord in the mid- to late 1950s, growing a small chain of restaurants that still operate today. Their hallmarks are their extra-wide burger patties and flashing neon signs. (Courtesy of Jimmy Auten.)

"Impact merchandising" was the goal of the 1964 remodel of downtown Concord's J. C. Penney store, with vertical displays and wide aisles. Penney's operated at 56 South Union Street in the P. M. Morris building for decades before relocating to Carolina Mall. At this writing, Tisun Beauty Supply is in this location.

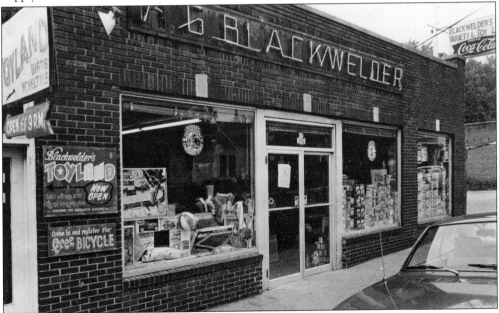

This exterior view of H. G. Blackwelder's Grocery, photographed in the late 1960s, reflects its remodel of a decade earlier, which included expanding from two windows to three. A narrow stairwell to the left of the grocery led to a wonderland for children called Blackwelder's Toyland, its shelves stuffed almost to bursting with the latest playthings.

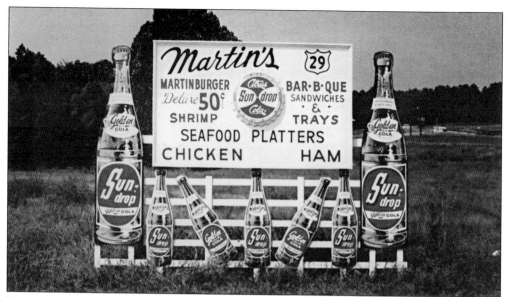

Margaret and Bill King started the Sun-drop Bottling Company in 1954 in Concord, distributing the Sun-drop soft drink in Cabarrus and surrounding counties. Its sparkling, refreshing taste made this "Golden Cola" a regional legend and spawned an in-demand variation, the Cherry Lemon Sun-drop. This 1960s roadside billboard promotes not only the soft drink but also a popular drive-in of the day, Martin's in Wil-Mar Park. (Courtesy of Sun-drop.)

This photograph by Edgar Readling shows Cabarrus Memorial Hospital as it appeared in the 1960s. It started in 1937 as Cabarrus County Hospital with 46 beds and 10 bassinets, and its steady expansion has kept pace with the growth of Concord. Today the facility is called Carolinas Medical Center NorthEast, a sprawling campus with a staff of 300 physicians working within 30 clinics.

Despite its name, the Charlotte Motor Speedway (formerly Lowe's Motor Speedway) is located in Concord. The speedway started in 1959 when Bruton Smith, a car dealer who promoted short-track races at the Concord Motor Speedway, partnered with stock car driver Chris Turner to build a 1.5-mile track on Highway 29 South just outside of Charlotte. The race in this photograph took place on June 15, 1960. Smith departed in 1962 but returned in 1975 as the speedway's major shareholder, hiring H. A. "Humpy" Wheeler as general manager. Under their leadership, the speedway has enjoyed high-octane growth, spinning off expanded grandstands, luxury suites, adjacent condos, a dirt track, and a drag strip, among other additions. Several movies have filmed scenes here, including *Speedway* starring Elvis Presley, *Days of Thunder* starring Tom Cruise, and *Talladega Nights: The Ballad of Ricky Bobby* starring Will Ferrell. Today the Charlotte Motor Speedway is one of the nation's premier motorsports attractions, with a multimillion-dollar network of hotels, restaurants, shopping centers, and housing developments nearby. (Photograph by T. Taylor Warren; courtesy of the *Charlotte Observer*.)

Photographer Frankie Furr aimed high to capture this balloon promoting the 1973 opening of Carolina Mall, the Concord area's first indoor shopping mall. Located on Highway 29 just north of the hospital, Carolina Mall adversely affected the downtown retail district; its introduction of a multiplex also led to the closure of the Cinema and Cabarrus movie theaters.

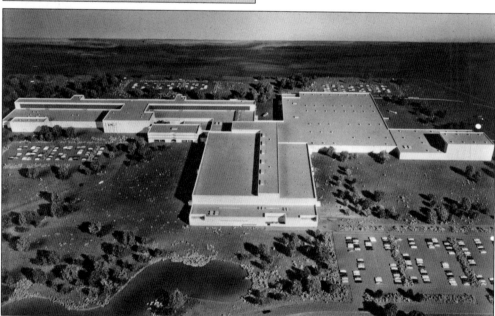

In 1981, this model of the Philip Morris cigarette plant, to be built on former dairy farmland in southwest Concord, promised a bright future. The plant opened in 1983 and was a major employer for over two decades. Those 2,500 jobs went up in smoke in 2007 when Philip Morris announced that it would close the facility. At this writing, the 2,000-acre site remains vacant. (Courtesy of the Concord Public Library.)

Six

AN ALL-AMERICAN CITY

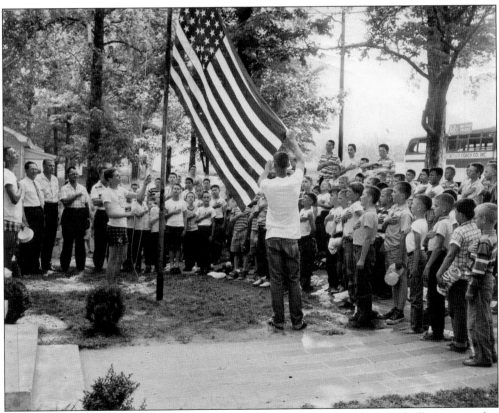

Area boys attending Concord's Camp Spencer start their day with the Pledge of Allegiance in this June 1958 photograph by Lawson Bonds. The three adults at the far left of the group are members of the Boys Club Board of Directors. From left to right, they are Howard Levin, Earl Propst, and Sam Colerider. (Courtesy of the Cabarrus County Boys and Girls Club.)

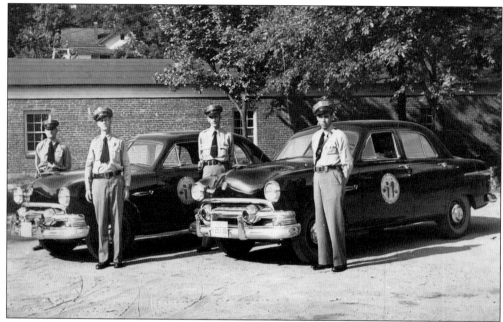

Four of Concord's finest stand proudly before two of the department's three police cars in this photograph taken by Jimmy Babb in November 1951. From left to right are Jack Moore, Clarence Cagle, Orrin Ussery, and Jim Moore. (Courtesy of the Concord Police Department.)

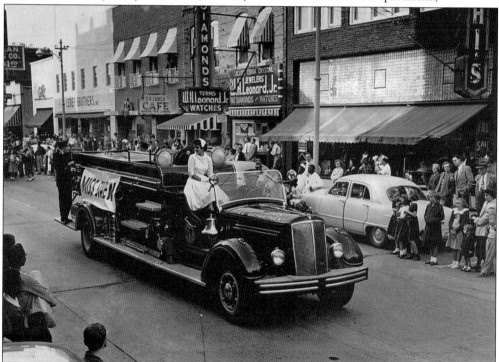

Fire Prevention Week culminated on October 8, 1953, with this parade in downtown Concord. Riding on the Concord Fire Department truck is "Miss Siren," Ann Williams, a senior at Concord High School. (Photograph by Lawson Bonds; courtesy of Rosemary Goodman.)

At an appreciation luncheon on February 18, 1955, business leader O. A. Swaringen (right) presented Cannon Mills president Charles A. Cannon with a recognition plaque for his myriad contributions to the community. The event was held at the Hotel Concord ballroom and was cosponsored by 10 area civic organizations. (Photograph by Earl Kelley; courtesy of the Kannapolis Public Library.)

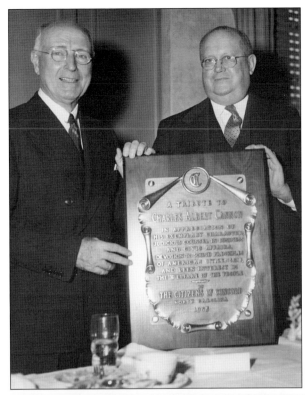

While in Chicago, Illinois, for the annual convention of Rotary International, members of the Concord Rotary Club and their spouses took in a White Sox game on Sunday, May 29, 1955. From left to right are Joe Davis, Malcolm Purnell, Neal Craig, Nancy Craig, Jane Davis, Fred Craven, and Ben Craven. (Courtesy of the Concord Rotary Club.)

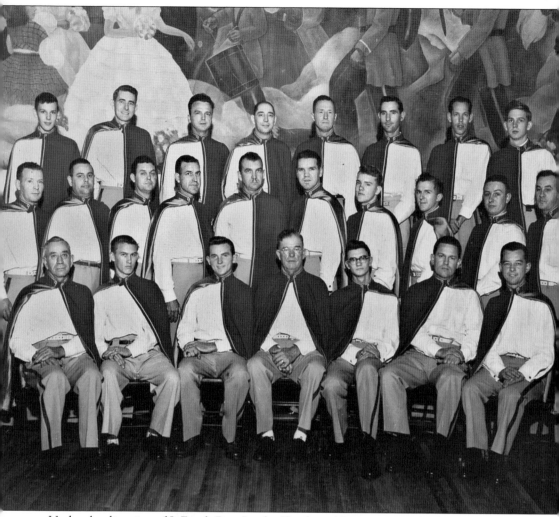

Under the direction of J. Frank Barr Jr., the Knights of Song was a male choral ensemble that performed in Concord civic functions and parades during the mid-1950s. Their elaborate uniforms included a gold "K of S" logo embroidered onto their maroon capes and Foreign Legion–style hats. This photograph by Edgar Readling was taken inside Memorial Hall, in front of the history mural. From left to right are (first row) Walter Sifford, Jack Yarbrough, two unidentified members, Fred Carriker, Pete Kilpatrick, and W. D. Lee; (second row) Casey Burrage, Leo Bonnevie, Bud Joyner, A. R. "Bud" Morrison, Hal Franklin Greene, Bill Furr, Wayne Haigler, Timmy Fry, Bobby Yow, and Jimmy Williford; (third row) unidentified, Vance Miller, J. P. McCall, Charles L. Phillips Sr., Foy Biggers, Charles Galloway, S. O. Stone, and Jack Stroud. (Courtesy of Frank Barr and David Phillips.)

Mayor and noted photographer Zack L. Roberts (right) welcomes Hopalong Cassidy (William Boyd) to Concord on November 26, 1956. On tour promoting the All Star Dairy products sold at the Cabarrus Creamery, "Hoppy" was greeted by a throng of clamoring children at his Boys Club appearance. Also visible are Donald Sams (left), Ben Holcomb (second from left), and Ted May (right). (Courtesy of Robert E. Burrage.)

Cherie Medlin, a seventh grader at Long School, won the 1962 Halloween window-painting contest with this spooky entry at H and W Clothing Store. During the 1950s and 1960s, Concord merchants allowed students to use temporary paint to illustrate Halloween scenes of ghosts and goblins on their windows. Observing is Charles Freeze, president of the Optimist Club, the sponsors of the annual event. (Photograph by Lawson Bonds.)

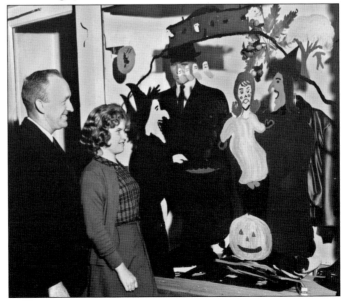

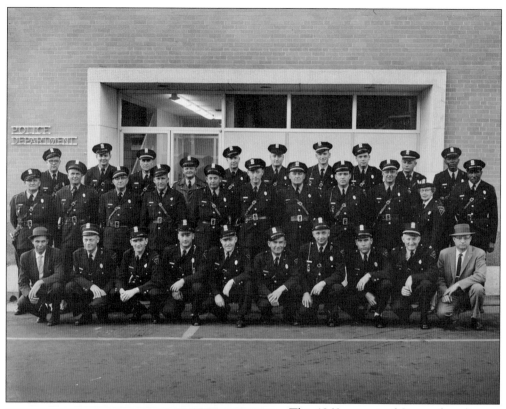

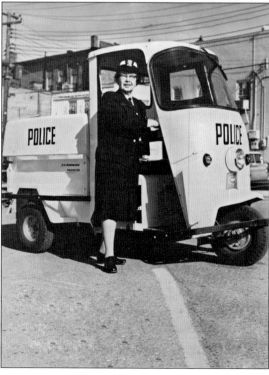

This 1960 portrait of Concord's police force was taken in front of the Police Department Building, which was at the west side of city hall, on Barbrick Avenue. From left to right are (first row) detective Jack Moore, Orrin Ussery, Don Davis, Larry Clay Sr., Wayne Honeycutt, "Shorty" Strickland, unidentified, Jack Parnell, Chief "Inky" Murr, and detective George Smith; (second row) unidentified, Alfred Ballard, unidentified, Lefty Burris, Marshall Goldston, two unidentified people, Richard Church, E. R. McKay, Esther Litaker, and Julius Franklin; (third row) Floyd Hall, unidentified, Harry Polk, Fleet McClamrock, five unidentified officers, and David Steele. An addition to the force's fleet is revealed in the photograph below, from January 1964, featuring meter-maid Esther Litaker and her new Cushman Truckster three-wheeled motorcycle. (Both, photographs by Edgar Readling; above, courtesy of George Smith and the Concord Police Department.)

In a scene described by photographer Edgar Readling as a "temporary madhouse," local children participated in an Easter-egg hunt behind Concord High School on Thursday, March 26, 1964. Heavy rains threatened to cancel the hunt but fortunately subsided in time for the fun to commence.

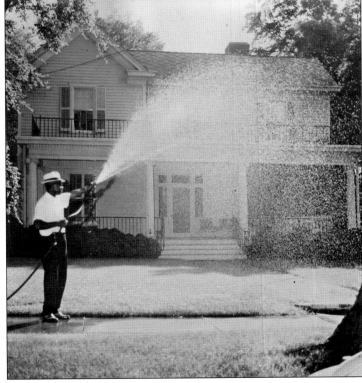

Wesley Jacobs dutifully tends to the thirsty lawn of Mrs. Guy Beaver of North Union Street in this slice-of-life photograph by Edgar Readling from June 1964.

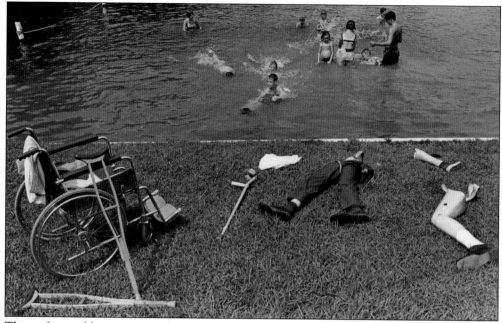

This unforgettable, inspirational photograph by Gene Furr was taken during the summer of 1964 at the "Crippled Children's Camp" at Camp Spencer, sponsored by the Kiwanis Club. (Courtesy of Gene Furr.)

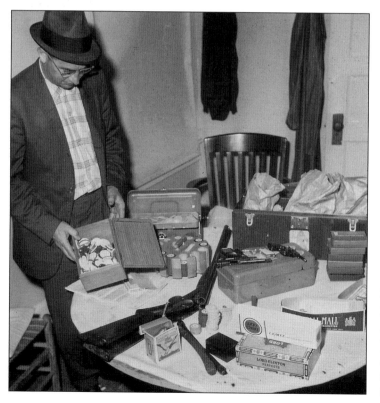

Cabarrus County sheriff J. B. Roberts examines locally seized contraband after an early-1960s raid. Roberts joined the sheriff's department in 1951 and became sheriff in 1956, holding that office until 1982. From the department's Concord headquarters, he frequently partnered with Concord Police Department officials, often working undercover. (Courtesy of Marty McGee.)

In 1965, the Cabarrus County Agricultural Fair, managed by Clyde L. Propst, was in its 12th year and featured the Deggeller Amusement Company's "Magic Midway." The weeklong fair attracted 23,000 visitors on Tuesday alone. Edgar Readling took the photograph at right of the double Ferris wheel, one of the fair's most popular rides. From its high point, a rider was spellbound by a sweeping vista of the city of Concord. The image below, from 1967, spotlights the agricultural aspect of the event and M. L. Harris's prize-winning cattle, Rocky River Jimbo and Harris Pretty Star. (Below, courtesy of Robert E. Burrage.)

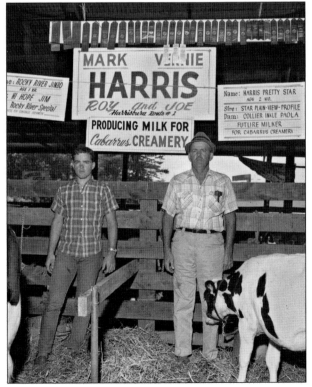

The building of Interstate 85 in North Carolina took years to complete, as various regions proceeded with road construction at different paces. This 1966 aerial photograph of north Concord reveals the snail-paced, meticulous process as it was underway. The stretch of Interstate 85 linking Charlotte and Durham was not finished until 1970. (Courtesy of Kenny Propst.)

The *Batman* television series of 1966 unleashed an international wave of "Batmania," prompting All Star Dairies to retire Hopalong Cassidy as its spokesperson for the Caped Crusader. The Cabarrus Creamery decorated this company car as Concord's own "Batmobile" and entered it in the 1966 Concord Christmas Parade. (Photograph by Lawson Bonds; courtesy of Robert E. Burrage.)

The staff of the *Concord Tribune* held its 1970 Christmas party at the American Legion post on Wilshire Avenue in Concord. While a complete listing of employees pictured is unavailable, attendees seen here include (listed alphabetically) Ronnie Almond, Colleen Andrews, Phyllis Andrews, Edith Bonds, Ken Campbell, Pedro Cayado, Betty Faye Clontz, Carolyn Eudy, Marvin Eury, Frankie Furr, Larry Harris, Don Hatley, Arthur Huckle, Betty Huckle, Helen Jenkins, Doris Johnson, Malcolm Jones, Wimp Kindley, Barbara McLester, Bob Moose, Larry Norris, Bill Overcash, Edgar Readling, Bill Ritchie, Bill Ross, Jack Smith, Richard Smith, Shelby Varnadore, J. B. Williams, and Tom Williams. (Courtesy of Shelby Varnadore.)

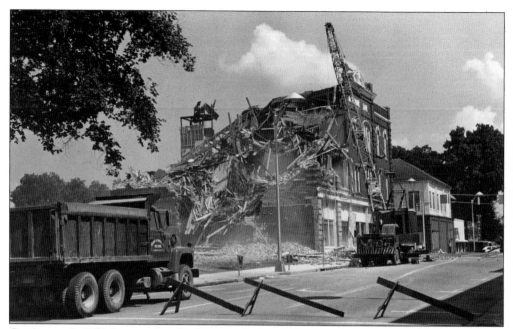

On August 9, 1972, Lawson Bonds photographed the demolition of the Allison Building, which stood for 114 years on the corner of South Union Street and Corban Avenue. It was torn down to make way for the new county courthouse. In its final incarnation, the building housed Kale-Lawing's third downtown location. The office of the *Concord Tribune* is visible down the street, at the right. (Courtesy of First Presbyterian Church.)

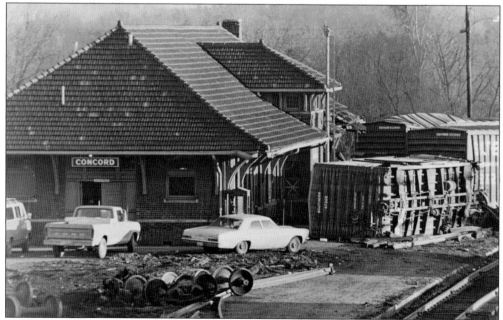

Bill Teal's photography hobby came in handy during the last week of January 1974 as he snapped pictures of a massive train wreck that occurred at the Concord Depot. From close-ups of twisted railcars to wide shots of rows of gawkers from the Cabarrus Avenue bridge overhead, Teal recorded over 150 photographs of this mishap. (Courtesy of William Teal.)

To countless Concord children in the 1960s and 1970s, the friendliest face at the Concord Police Department was Sgt. Richard Church. His "beat" was the local schools, which he frequented, sharing safety tips with students. He also hosted tours of the department and its law-enforcement equipment. (Courtesy of George Smith and the Concord Police Department.)

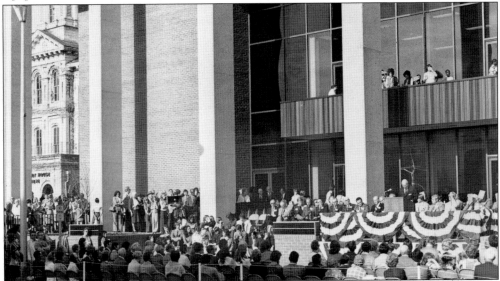

The current Cabarrus County Courthouse was dedicated in a special ceremony that attracted an estimated 800 people on Sunday, November 2, 1975. Dr. Albert Coates, founder and director of the North Carolina Institute of Government, was the keynote speaker, challenging attendees to live up to their civic responsibilities and not cater to extreme political views. The cost of the courthouse was $2.2 million. (Courtesy of the Kannapolis Public Library.)

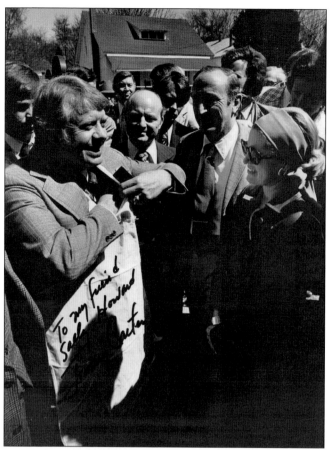

Georgia governor Jimmy Carter visited Concord in March 1976 while campaigning for the U.S. presidency, donning a white apron and flipping flapjacks at the Boys Club's annual pancake breakfast. Jim Wilson photographed Carter and, from left to right, city councilman Harold McEachern, Mayor Alfred Brown, and Sally P. Howard for the *Charlotte Observer*. As president, Carter, with vice president Walter Mondale, welcomed Concord's James Alexander (photograph below, left) to the White House's Roosevelt Room to congratulate him for being selected as the first runner-up in the Boys Clubs of America's National Boy of the Year competition. To the right of Alexander is Cabarrus County Boys Club executive director Hank Utley. (Left, courtesy of Sally P. Howard; below, courtesy of Jim Helms.)

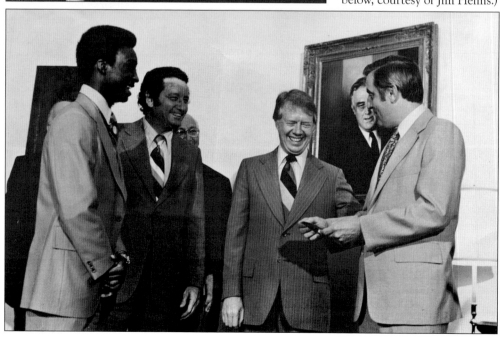

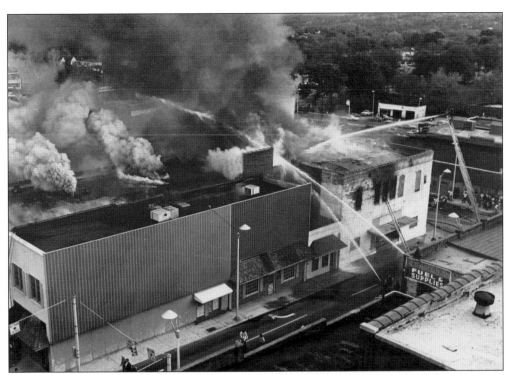

Smoke strangled downtown Concord on Friday, April 14, 1978, when the old Efird Building, on South Union Street two doors down from the square, caught fire. It took 70 firemen and two hours of crisscrossing torrents of water to extinguish the blaze. The Glamour Shops, the building's tenant, and nearby businesses, including Rhinehardt's Interiors, Roberts Camera Store, and Porter Drug Company (shown in the image below), frantically hustled valuables out of their stores, fearing the worst. (Above, photograph by Edgar Readling, courtesy of George Smith; below, courtesy of the Concord Fire Department.)

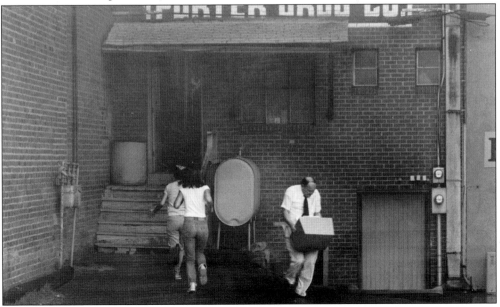

In addition to providing services for people with vision impairment, the Concord Lions Club has long served the community by placing U.S. flags around the city during patriotic holidays. This late-1970s photograph by Frankie Furr shows Lion Gene Linker gathering flags after an event.

This photograph from Monday morning, January 31, 1979, reveals the smoldering aftermath of the Kerr Bleachery fire of the night before. Igniting under still-undetermined circumstances during third shift on Sunday, the fire quickly engulfed the plant, completely destroying the business and leaving hundreds unemployed. (Courtesy of the Concord Fire Department.)

The Old Courthouse Theatre originated in May 1976 as part of a movement to spare the 1876 Courthouse from demolition, performing in the building's former courtroom. Since 1984, it has operated from the 1923 First Baptist Church on Spring Street. Seen here in an April 1981 performance of *Gigi* are (left to right) Cynthia Teague (Gigi), Ron Seabolt (Charles), and Clare Cook (Aunt Alicia). (Courtesy of the Old Courthouse Theatre.)

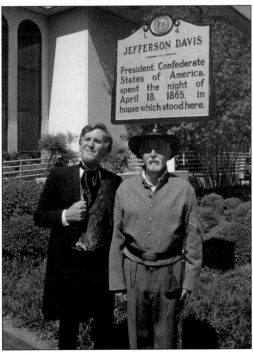

Historic Cabarrus Association launched its first annual Walk Through Concord's History on Saturday, April 25, 2009. This unique outreach event combined historical reenactments and a fund-raising walk-a-thon, with costumed reenactors bringing to life community events along the walk route. Confederate president Jefferson Davis (George Pfeffer) and his guard (Jim Kee) revisit the site of Davis's night in Concord in this photograph.

The Concord Rotary Club held the groundbreaking for its "Everybody Plays" project at McGee Park on June 30, 2010, having raised $110,000 in less than a year to build a playground accessible for children with disabilities. From left to right are former mayor Harold McEachern, Concord mayor Scott Padgett, Venetia Skahen, J. C. McKenzie, Maggie Turner, Amanda Turner, Debby Abernathy, Bob Dowless, Wayne King, and Bill Hughes.

The Avett Brothers were catapulted beyond their Concord roots after their 2007 performance on *Late Night with Conan O'Brien* put them under a national spotlight. With their fusion of folk, rock, bluegrass, and honky tonk, siblings Scott Avett and Seth Avett, with bassist Bob Crawford, continue to garner concert crowds and music awards. (Photograph by Crackerfarm; courtesy of Dolph Ramseur.)

BIBLIOGRAPHY

Arthur-Cornett, Helen. *Remembering Concord: Articles from the* Look Back *Collection*. Charleston, SC: The History Press, 2005.

City of Kannapolis, NC. *Kannapolis: A Pictorial History*. Kannapolis, NC: Jostens, 2008.

Cozart, Leland Stanford. *A Venture of Faith: Barber-Scotia College, 1867–1967*. Charlotte, NC: Heritage Printers, Inc., 1976.

Davis Jr., Bernard. *Portraits of the African-America Experience in Concord-Cabarrus, North Carolina, 1860–2008*. Bloomington, IN: Xlibris Corporation, 2010.

Horton Jr., Clarence E., editor. *A Bicentennial History of Concord: From the Pages of* Progress Magazine. Concord, NC: Historic Cabarrus, Inc., 1999.

Kaplan, Peter R. *The Historic Architecture of Cabarrus County, North Carolina*. Concord, NC: Historic Cabarrus, Inc., 2004.

Patterson, George Michael. *Concord and Cabarrus County in Vintage Postcards*. Charleston, SC: Arcadia Publishing, 2001.

Rankin Jr., Edward L. *A Century of Sodas: 1904–2004*. Concord, NC: Concord Printing Company, 2004.

Rouse, J. K. *The Noble Experiment of Warren C. Coleman*. Charlotte, NC: Crabtree Press, 1972.

www.arcadiapublishing.com

Discover books about the town where you grew up, the cities where your friends and families live, the town where your parents met, or even that retirement spot you've been dreaming about. Our Web site provides history lovers with exclusive deals, advanced notification about new titles, e-mail alerts of author events, and much more.

Find Your Place in History.